ZOOGAMI

fold your own origami wildlife park

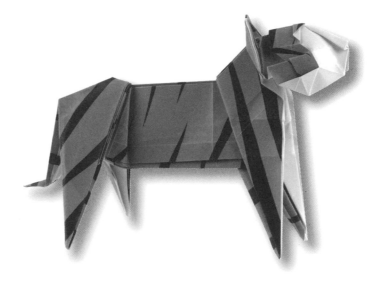

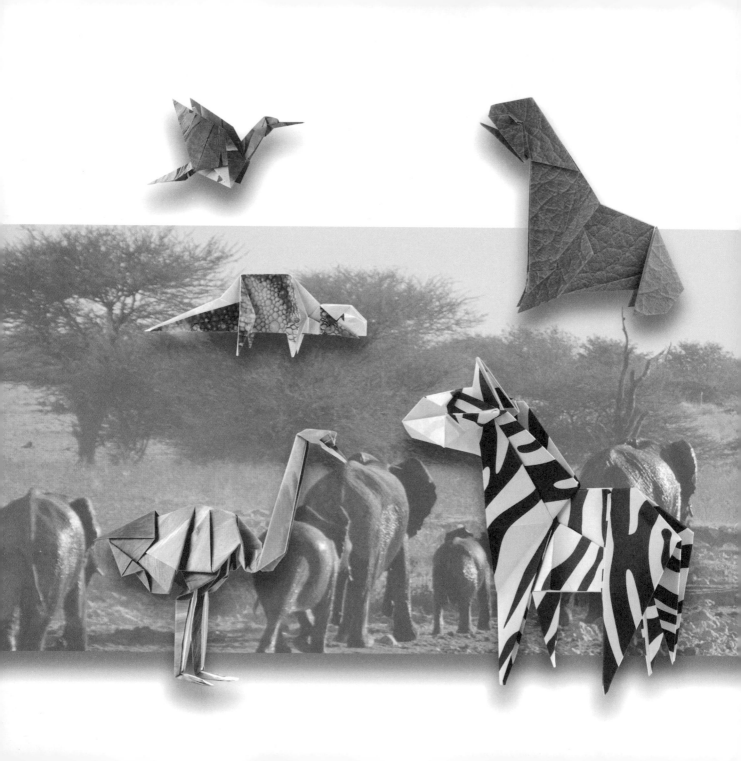

ZOOGAMI

fold your own origami wildlife park

mark bolitho

HARPER
DESIGN
An Imprint of HarperCollins Publishers

HarperCollins books may be purchased for educational, business, or sales promotional use. For information please e-mail the Special Markets Department at SPsales@harpercollins.com.

First published in 2014 by
Harper Design
An Imprint of HarperCollins *Publishers*
10 East 53rd Street
New York, NY 10022
Tel: (212) 207-7000
Fax: (212) 207-7654
www.harpercollinspublishers.com
harperdesign@harpercollins.com

Distributed throughout the world by
HarperCollins *Publishers*
10 East 53rd Street
New York, NY 10022

ISBN 978-0-06-231548-9

Library of Congress Control Number: 2013951057

Printed in China

First Printing, 2014

Creative Director: Sean Keogh
Designer: Kathryn Wise
Editor: Anna Southgate
Production Manager: William Protheroe
Photographer: JAX © Keo Design Ltd

Front cover illustrations: leaves © xalex / Shutterstock,
illustration of grass © iadams / Shutterstock
Cover photographs by JAX © Keo Design Ltd

contents

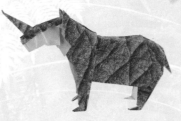

introduction

Paper folding is an art form that is probably as old as paper itself. From traditional designs passed from generation to generation to sophisticated, complex designs that were invented in the last fifty years, the art of paper folding, or origami, continues to be one of the most popular crafts worldwide.

The word *origami* is the Japanese word for paper folding, and the practice itself is generally associated with Japan. In the 1950s, origami societies outside Japan began adopting the Japanese name, which has since become the internationally recognized name for the art.

The earliest recorded folded paper designs originated from woodblock prints in a Japanese book titled *Ranma Zushiki* (1734). The book featured folded paper images including the traditional crane, a four-legged box, and a boat. The earliest origami instruction book is thought to be *Senbazaru Orikata* ("The secrets of one thousand cranes origami"). Published in 1797, it includes instructions for creating the traditional crane design. The crane featured in *Senbazaru Orikata* is probably the most well-known and popular of all origami designs, due to its simplicity—with a few folds, the finished model has two wings, a head, and a tail.

In the last fifty years, with the advancement of paper technology, origami designs have become more complex. Early manufactured paper was not nearly as malleable as its present-day counterpart, and the quality of paper produced in the past limited the level of technical complexity that could be achieved. As paper technology advanced, larger, thinner sheets of paper could be produced and new folding possibilities realized, making origami ever more popular as both an art form and a craft.

Perhaps one of the most compelling aspects of origami is that there are no strict rules. Although the traditional school of thought advocates that a classic origami model should be folded from a square that is never cut, it is not uncommon for new designs to call for cutting. But in keeping with traditional origami methods, all the models in this book are made from squares of paper and do not require cutting. This book also includes a section of specially designed patterned paper that is meant to mimic the fur, feathers, and skin of each animal featured. Should you wish to make more than one of each animal, you can photocopy or scan the paper to print out more, or cut the squares down in size to make smaller creatures.

A successful origami design captures some of the look of the object it represents. A successful animal design captures the essence of the creature—perhaps the shape, or the tilt of the head. *Zoogami* is a collection of origami animals that have been grouped into sections based on their locations at the zoo, from the aquarium to the mammal house, the aviary, and the reptile house. Each design has step-by-step instructions and diagrams that use standard origami notation to help you create the model. *Zoogami* lets you experience the fun of creating interesting models by allowing you to follow the folding journey and see the model evolve at your fingertips.

A truly unique book, *Zoogami* will help anyone create their very own paper wildlife park.

materials and equipment

All the projects in this book can be assembled using squares or rectangles of paper. The papers in the back of this book are numbered to correlate to the respective model. The paper used is also identified on the left-hand side of the page. It is possible to make four animals from one sheet of paper by simply cutting the paper into fours. Here is a list of the basic tools you will need.

All you really need to create origami is a pair of hands and a piece of paper. To achieve the best results, keep your hands clean, and use your fingers to manipulate the paper, however, the tools described below will help to make the folding and creasing processes much easier.

BONE FOLDER
You can use various devices to enhance folding. The bone folder is a tool used in the bookbinding industry. It can be used to sharpen the crease of a fold by applying smooth, strong pressure along it. Although they were originally made of bone, plastic versions are now available, too. You can also use everyday items to help you sharpen creases—a large marker pen will do the job just as well, for example.

CHOPSTICKS
A chopstick can be very useful for manipulating the inside of a model, particularly to work on the detail and create points.

GUILLOTINE
A guillotine offers the simplest way to safely cut long, straight lines. The best results can be achieved by pulling the cutting blade toward you in a single smooth action.

SCISSORS
A good, sharp pair of scissors is invaluable for cutting paper. The best have long, straight cutting blades.

basic techniques

There are a few basic techniques that, when mastered, render paper folding easier and more fun. With practice they will make even the hardest of models easier to complete.

The folding process for each model in this book is illustrated using step-by-step diagrams. Alongside the diagrams you will find arrows and fold lines that show how each fold should be carried out. These are all explained on the following pages. It is worth familiarizing yourself with them.

SYMBOLS

	Fold
	Fold and unfold
(2)	Fold over two layers
	The next step will show the model turned over
	Repeat steps
(4–8)	Repeat steps 4 to 8
	Repeat behind
×3	Repeat three times
	Inflate the model
	Squash or sink the paper inside itself
	Viewpoint
	X-ray view
90°	Rotate the model 90°
	Cut
	Hold the model here

THE SYMBOLS USED IN THIS BOOK ARE BASED ON STANDARD ORIGAMI NOTATION

BASIC FOLDS

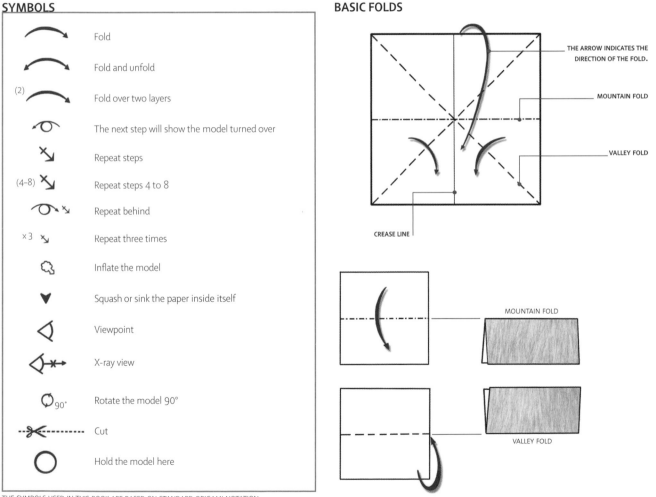

THE ARROW INDICATES THE DIRECTION OF THE FOLD.

MOUNTAIN FOLD

VALLEY FOLD

CREASE LINE

MOUNTAIN FOLD

VALLEY FOLD

Most of the projects in this book begin with the paper pattern-side down. The diagrams show the construction process broken down into steps that present one or two folds each. Each diagram shows the current stage of the model and explains how to move on to the next.

Before attempting a step, make sure that your model resembles the step diagram. Look ahead to the next stage to see what the model will look like after the folds have been applied. Each diagram shows where to make each fold, with either mountain or valley fold lines. The red arrows show the direction of the fold.

When you have completed a step, look at the model carefully to see if it resembles the next step. If your model does not look right, you may have missed a fold or made a wrong fold. Don't worry—just look closely at the instructions and work back until you can match your model with an earlier step.

FIVE GOLDEN RULES FOR SUCCESSFUL FOLDING

1	Follow the steps in numerical order, and fold one step at a time.
2	Look out for the reference points, both in the step you are trying to complete and in the next step, to see how the model should look when the fold is completed.
3	Fold as accurately as possible. If the step requires the model to be folded in half, fold and match the two edges of the model together and then make the crease.
4	Fold on a flat, level surface. You can fold in the air, but it is easier to make clean, accurate folds on a flat surface.
5	Make creases as sharp as possible. It may help to enhance the creases by running a fingernail or object such as a bone folder along the folded edge.

FOLLOWING INSTRUCTIONS — EXAMPLE

In this step, the corners of the model are folded in. When step 18 is completed, the model will look like the image in step 19.

18 Reverse fold the point in front.

19 Looking ahead to the next step will show you how the completed fold should look.

BASIC TECHNIQUES

FOLDING IN HALF

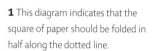

1 This diagram indicates that the square of paper should be folded in half along the dotted line.

2 First, line up the opposite edges and hold them together.

3 Pinch at the center of the folded edge and make the crease, smoothing from the center out toward each edge.

4 Keep holding the edges together as you sharpen the crease. The paper is now folded in half.

MAKING A SQUARE FROM A RECTANGLE

Always start with a true rectangle—all four corners must be 90°.

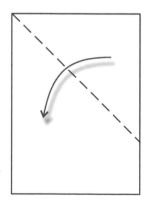

1 Fold the top edge of the paper diagonally so that the top edge aligns with the left-hand edge.

2 Fold and unfold the bottom edge of the paper up to the base of the triangle you have just made. Cut along this folded edge.

3 Unfold the triangle. The square is now ready for use.

4 You now have a square and an extra rectangle of paper.

REVERSE FOLD—INSIDE REVERSE FOLD

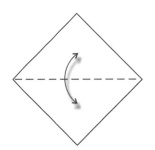

1 Fold and unfold the square of paper diagonally into a triangle.

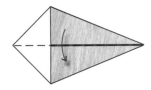

2 Fold the edges to align with the middle crease of the paper, as shown.

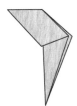

3 Fold the model horizontally in half along the middle crease.

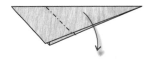

4 Fold the outside edges in. When these folds are made simultaneously, the point will fold in.

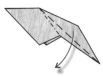

5 This interim stage shows how the point of the model reverses into itself.

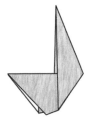

6 The reverse fold is now complete.

REVERSE FOLD—OUTSIDE REVERSE FOLD

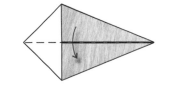

1 Follow steps 1 to 3 of the inside reverse fold.

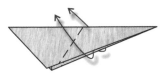

2 Apply a valley fold to either side of the point causing the point to turn inside out.

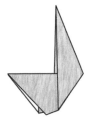

3 The outside reverse fold looks like this when it is complete.

REVERSE FOLDS COMBINED—BIRD'S FOOT

The bird's-foot process involves two reverse folds. One is into the model; the second reverses the point back out again.

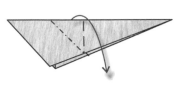

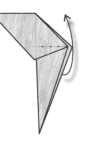

1 First, a mountain fold reverses the point down into the model.

2 Second, a valley fold reverses the point of the model back up again.

3 The bird's-foot fold will look like this when it is completed.

PRELIMINARY BASE

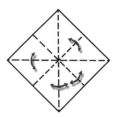

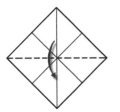

1 Fold and unfold the square of paper in half horizontally, vertically, and diagonally.

2 Fold the square in half along one of the diagonal creases.

3 Fold in half again, vertically along the center fold of the model.

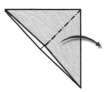

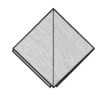

4 Slip a finger inside the top layer of the base and lift the paper upward.

5 Squash the paper down accurately over the lower layers to flatten the point.

6 Turn over and repeat steps 3 to 5 on the other side to complete the preliminary base.

CRIMP FOLDS—OUTSIDE CRIMP FOLD

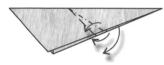

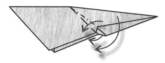

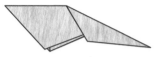

1 To form an outside crimp fold, first fold either side of a point to angle it up or down.

2 Fold the right side of the tip over the left side. The folds on either side of the point will mirror each other.

3 The outside crimp fold will look like this when it is completed.

CRIMP FOLDS—INSIDE CRIMP FOLD

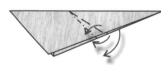

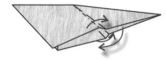

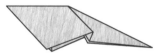

1 This fold applies folds is the reverse of the outside crimp fold: folds are applied to the inside.

2 Fold the edges out, causing the left section to fold over the right.

3 The inside crimp fold will look like this when it is completed.

BIRD BASE

Start with the completed preliminary base (shown on page 13).

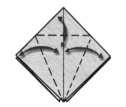

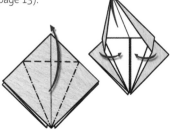

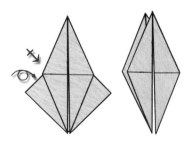

1 Fold and unfold the side edges into the middle and the top corner down, as shown.

2 Lift up the top layer and fold along the top crease. Fold in each of the sides.

3 Turn over and repeat steps 1 and 2 on the other side. The bird base is now complete.

SINK FOLD—METHOD 1

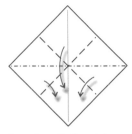

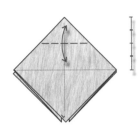

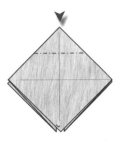

1 Fold horizontally, vertically, and diagonally along the dotted lines to make a preliminary base.

2 Fold and unfold the tip to the fold made in the previous step.

3 Reverse the point of the model down into itself. This is a sink fold.

SINK FOLD—METHOD 2

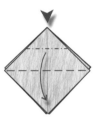

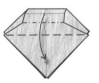

1 Alternatively, follow steps 1 and 2 of method 1. Fold the top corner over the middle and reverse the fold above.

2 Continue the fold and open the paper above. Flatten the top.

3 Fold the edge back up and refold the sides up again. The fold is complete.

WATERBOMB BASE

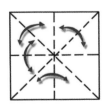

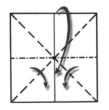

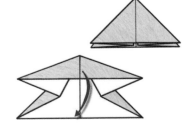

1 Fold and unfold the square in half horizontally, vertically, and diagonally.

2 Fold the square in half horizontally and reverse the folds in the diagonal creases.

3 Fold and flatten the model to complete the waterbomb base, as shown at top right.

tropical fish

Tropical fish are very popular as aquarium fish due to their bright and varied coloration. Freshwater fish typically get this coloration from iridescence, while saltwater tropical fish, often referred to as marine, are pigmented.

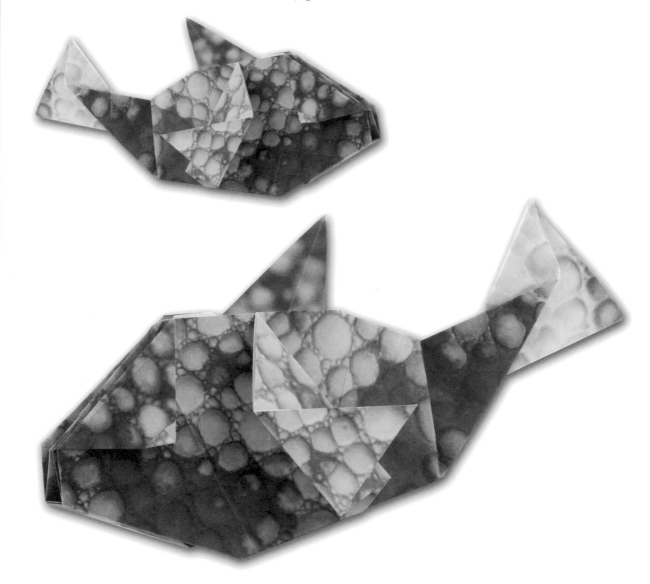

1

1

2

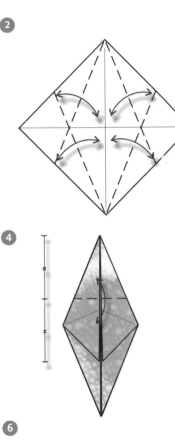

3

4

5

6

1 Start with a square piece of paper, colored side down. Fold and unfold it in half diagonally in both directions.

2 Fold and unfold all four sides of the paper diagonally to align with the middle crease.

3 Refold the creases just made. Where the edges fold together to a point, pinch the corners together and fold them down.

4 Fold and unfold the tip of the point up toward the folded corners. Use the rule at the side of the diagram to gauge the proportions of the folds.

5 Open out the paper in the upper section. Gently pull the edges of the paper to the outer folded edge and then fold the top point down.

6 Fold the point of the front layer up. It should be slightly below the midpoint between the point and the top folded edge.

> >

tropical fish—continued

7 Fold the edges of the triangle in on both sides. The point made by this process should extend beyond the folded edge below.

8 Fold the outer edges in to the middle crease. Keep the folded triangle on top of the folded edges.

9 Crease the line between the tip of the model and the folded triangles. Reverse this fold into the model.

10 Rotate the model 90° counterclockwise, and then fold the model in half behind, as indicated.

11 Fold the front top left corner over. Also fold over the triangle in the middle section along the dotted line shown in the diagram. Repeat the folds on the other side.

12 Fold and unfold the top right corner. Fold the middle triangle back. Then fold over a tip of the front triangle and flatten it. This will form one of the fish's eyes. Repeat the process on the other side of the model.

7

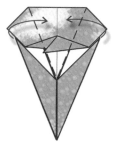

8

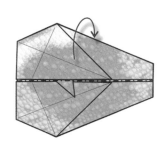

9

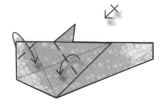

10

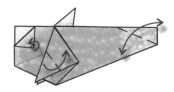

11

12

13

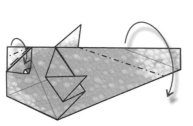

14

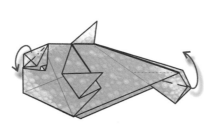

15

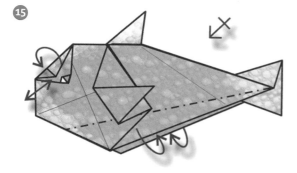

16

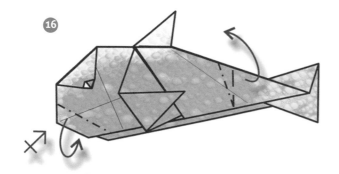

13 Reverse fold (see page 12) the top right side into the model. This will start to form the tail. Then fold over a triangle at the front. Raise it up and smooth it flat.

14 On the right side, fold up the layer behind to continue shaping the tail. Fold the triangle at the front of the fish behind.

15 At the front, tuck the folded triangle under the layer beneath. Then fold the lower edges of the fish's belly behind and into the model on both sides. Repeat the folds behind.

16 Crimp fold the tail (see page 14) into the body. At the front, fold the lower edge behind on both sides.

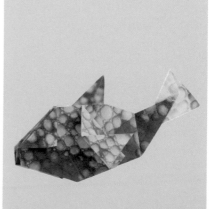

SEA WORLD—TROPICAL FISH

elephant seal

Elephant seals spend upwards of 80 percent of their lives in the ocean. They can hold their breath for more than one hundred minutes—longer than any other seal.

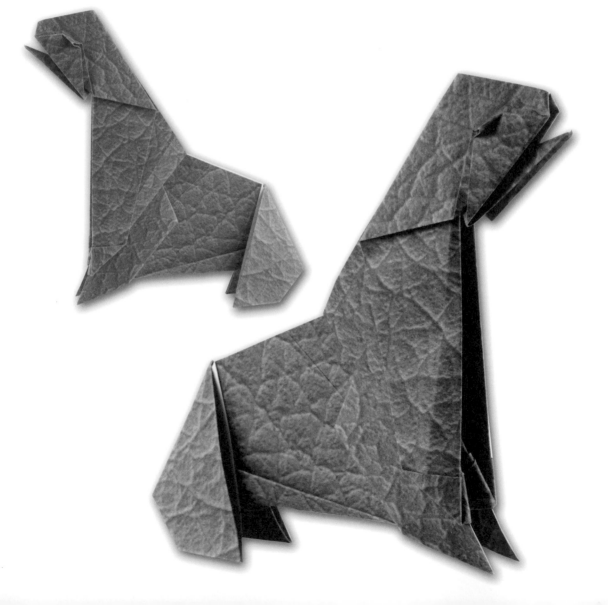

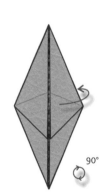

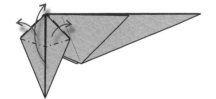

90°

1 Start with a square piece of paper, colored side down. Fold and unfold the square in half diagonally in both directions.

2 Fold and unfold the four sides diagonally to align with the middle crease.

3 Refold the creases made previously. Where the edges fold together, make a point. Pinch it together and fold it down.

4 Fold the model in half behind. Then rotate the model 90° counterclockwise.

5 Fold the left-hand point at a right angle midway between the right tip and the tip of the folded corner. Open the layers out and flatten the point down.

6 Fold the point up again, gently pull open the layers, and flatten the point. This forms the base of the flipper, so all the folds must be sharp and accurate.

SEA WORLD–ELEPHANT SEAL

> >

elephant seal—continued

2

7 Fold the tip of the point behind and gently tuck the section into the pocket that has been formed behind. Use the rule in the diagram to determine the proportions of the folds.

8 Fold the top layer back over in the direction indicated.

9 Fold the triangular point to the left. Turn the model over and repeat on the other side.

10 Fold the point of the triangle back over to the previously made crease line. Repeat the folds on the other side.

11 Shape the model by folding in the lower edge. Reverse fold the tip of the triangular section behind. Repeat on the reverse side.

12 Fold up the layer behind. Reverse fold the paper on the right side and flatten the model.

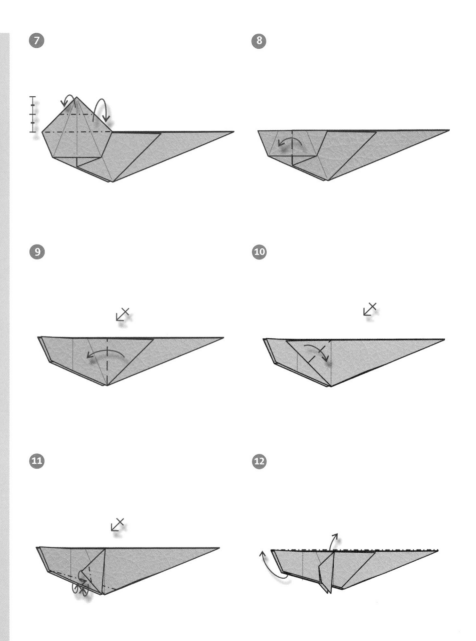

13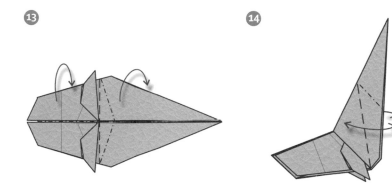

14

15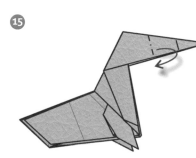

16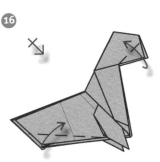

17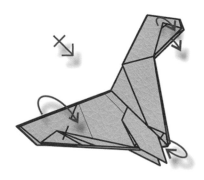

13 Fold the model in half behind, and fold the front point back and up again. This is a crimp fold (page 14) and will form the neck of the seal.

14 Begin to shape the head by folding the edges over on both sides, as indicated. This will cause the tip to fold over.

15 Reverse fold (see page 12) the point into the model and then fold it out again.

16 Continue forming the head by folding the upper right corner up. At the rear, fold up the lower edge, then repeat on the other side.

17 Create the rear flippers by folding over the lower corners. Fold over the tip of the triangle of the head to make an eye. Repeat on the reverse side. Slide down the lower inside layer of the head to open the mouth.

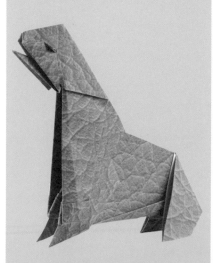

SEA WORLD—ELEPHANT SEAL

humpback whale

Humpbacks are found near coastlines. They feed on krill, plankton, and small fish. They migrate annually from summer feeding grounds near the poles to warmer winter breeding waters closer to the equator.

3

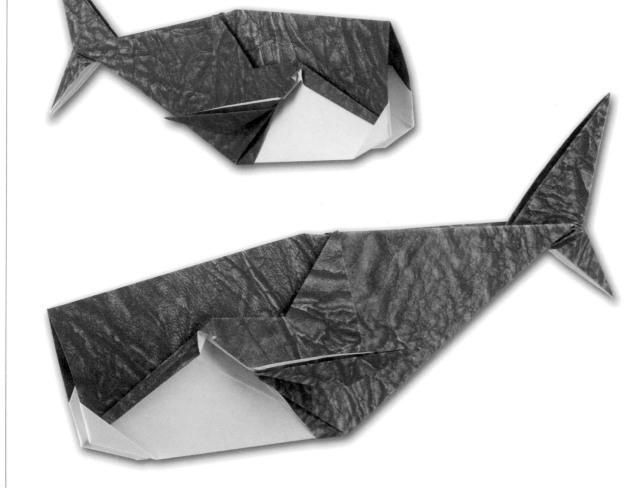

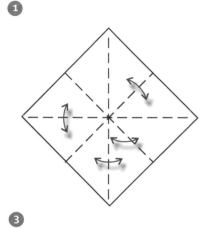

1 Start with a square piece of paper, colored side down. Fold the square in half lengthwise and diagonally on both sides, then unfold.

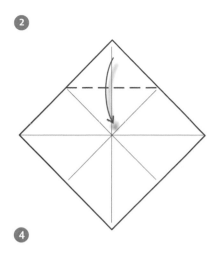

2 Fold the top point down to the center of the creases in the paper. Smooth to sharpen all of the folds.

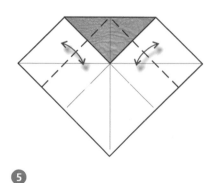

3 Fold and unfold the sides of the paper to the middle diagonal crease.

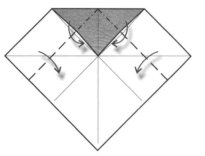

4 Refold the folds previously made. The edges should now fold under the top folded triangle created in step 2.

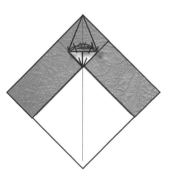

5 Lift up the left-hand point, open up the layers, and squash the point.

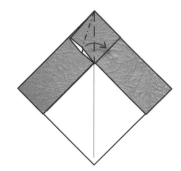

6 Fold and unfold the outer edges of the folded section to the middle crease, as indicated.

> >

humpback whale—continued

7 Hold the lower edge of the top section and fold it up along its middle. This will reverse the fold you made in the previous steps.

8 Fold the small point down along the horizontal crease previously made.

9 Fold the layer over. Now repeat steps 5 to 9 on the right–hand corner.

10 Fold up the lower point as shown; then turn the model over.

11 Now fold the left and right edges of the paper into the middle to align with the center crease.

12 Fold the model in half behind. Then rotate the model counterclockwise by 90°.

13 Fold the edge of the folded section behind. This will cause the layer below to fold up where indicated. Repeat on the other side.

14 Fold down the newly formed point. This will cause the layer beneath to open—these will form the whale's fins. Flatten these folds and then repeat them on the other side.

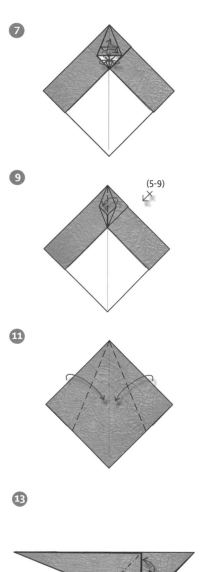
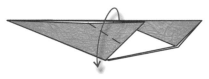

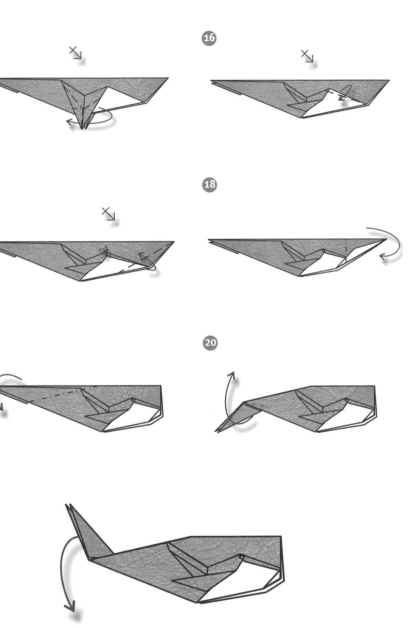

15 Continue forming the fins by folding the edges of the point together. Then fold the tip back. Repeat on the other side.

16 Fold over the edge of the folded section. Repeat on the other side.

17 Pull out the trapped paper and squash it to make an eye. Fold up the front corner. Repeat behind.

18 Push the right–hand point down and back into the model, as indicated, along the dotted lines to create the front of the whale.

19 Start forming the whale's tail by reverse folding the left side of the model.

20 Fold both layers of the whale's tail back up again as indicated.

21 Reverse fold the inner layer of the tail down to finish forming it.

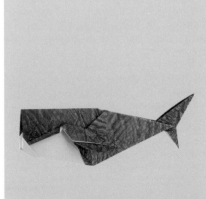

emperor penguin

Penguins are highly adapted for life in the water. Their wings evolved into flippers that help them glide effortlessly through the water. They feed on sea life that they catch while swimming underwater, and they spend about half their lives on land and half in the ocean.

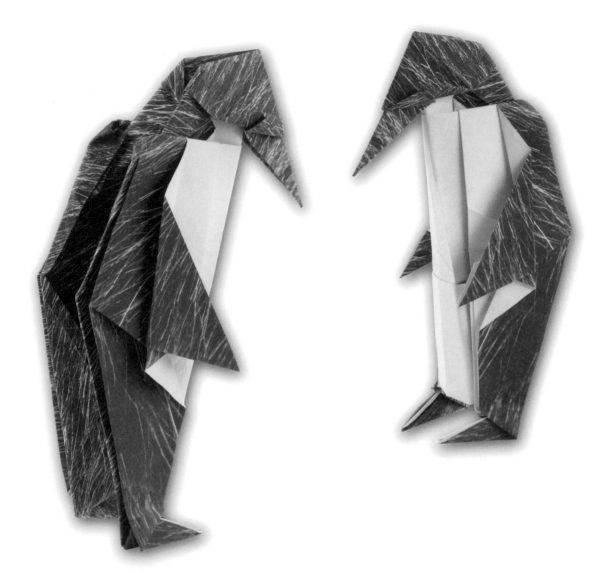

1

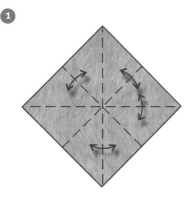

2

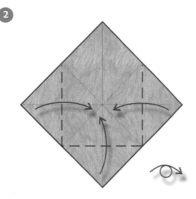

3

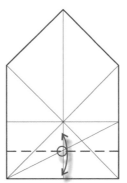

4

5

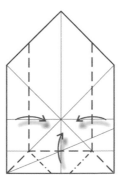

6

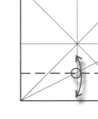

1 Start with a square piece of paper, colored side up. Fold the square in half horizontally, vertically, and diagonally, and then unfold.

2 Fold three of the corners of the paper to meet in the middle. Turn the paper over onto the blank side.

3 Bring the lower right corner up to touch the middle horizontal crease. Fold and unfold.

4 Fold and unfold the lower edge up along a crease that intersects the fold made in the previous step and the middle crease.

5 Fold and unfold the left and right edges. The fold should go through the crease made in the previous step and the diagonal creases made in step 3.

6 Refold the folds made in all the previous steps, then fold the edges together and flatten.

\>\>

emperor penguin—continued

7 Pull the corners of the front layer out from behind the front layer to form a square shape.

8 Fold and unfold both sides of the square into the folded edge.

9 Fold and unfold the left and right corners in to the midpoint of the lower middle section, as indicated.

10 Refold the folds you made in the previous two steps. Where the folds meet, make downward-facing points.

11 Fold in both edges of the top to touch the center crease line. Turn the model over.

12 Fold the top section down and then up again, using a zigzag movement. Fold in the two outer corners in the lower section. Turn the model over.

13 Fold out the triangles in the middle section. This will cause some reverse folds to form in the layer beneath.

14 Fold the top down to the right so that the tip touches the folded edge below, indicated by the red circle.

7
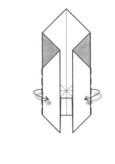

8
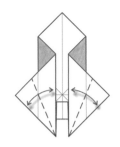

9
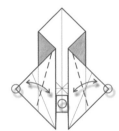

10
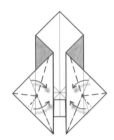

11
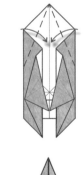

12
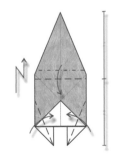

13
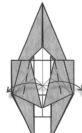

14
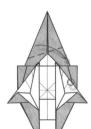

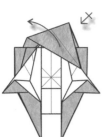

15

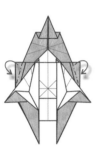

17

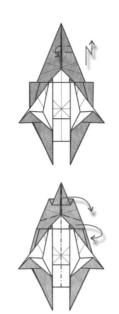

16

18

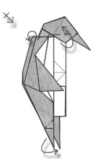

19

20

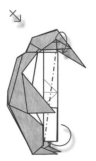

21

15 Fold the top of the penguin's head back up, then repeat the fold on the point on the left side of the model. Unfold.

16 Carefully fold the top of the point down and then up again, causing a zigzag fold.

17 Fold the left and right corners of the middle section of the model behind.

18 Start forming the head of the penguin: first fold the model in half behind, then refold the folds made in steps 16 and 17.

19 Fold the wings back over on both sides and then fold the edge of the neck into the model. Repeat on the other side.

20 Fold up the lower corner of the head. Fold the tips of the legs back and out again to bird's foot the feet (see page 13). Repeat on the other side.

21 Fold the tip of the folded triangle over to make an eye. Repeat behind. Make some creases in the body to shape the model.

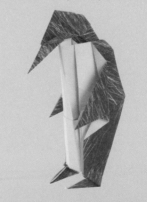

SEA WORLD—EMPEROR PENGUIN

common octopus

The pigment cells and muscles in the octopuses skin enable them to match the colors, forms, and textures of their surroundings making it difficult for predators to find them.

5

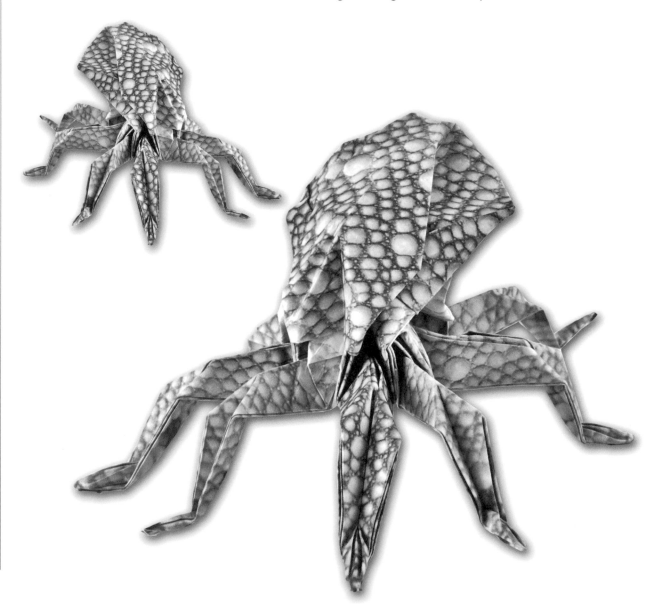

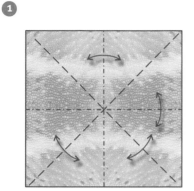

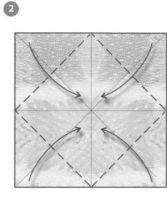

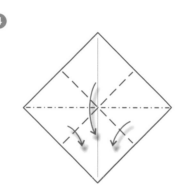

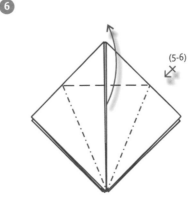

(5-6)

1 Start with a square piece of paper, colored side up. Fold and unfold the square in half horizontally, vertically, and diagonally. Ensure that the lengthwise folds are mountain folds (see page 9).

2 Fold the four corners diagonally into the center so that the four points meet exactly in the middle of the paper.

3 Turn the paper over, right to left, and fold on the other side.

4 Refold the folds made in step 1 to form a preliminary base (see page 13).

5 Fold and unfold the left and right sides in to the middle. Then fold and unfold the top triangle down to the center.

6 Fold the front layer up along the horizontal crease made in step 5. Repeat steps 5 and 6 on the other side.

common octopus—continued

7 Pull out the paper behind the folded points. Repeat the process on the other side.

8 Fold the front layer down. At the same time, fold both sides in diagonally. Repeat behind.

9 Fold one layer of the top section over to touch the middle crease.

10 Fold the two lower left–hand triangular points back over to the right.

11 Fold the two triangular points back again, to the middle crease line. Now unfold all the creases made back to step 9.

12 Repeat steps 9 to 11 on the left side of the model. Then repeat steps 9 to 11 on both sides of the other side of the model.

5

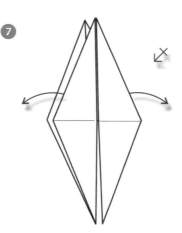

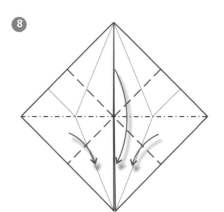

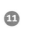

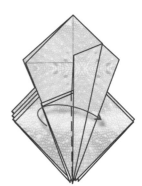

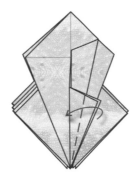

(9-12)

(9-12)

13

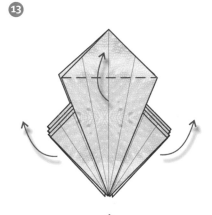

14

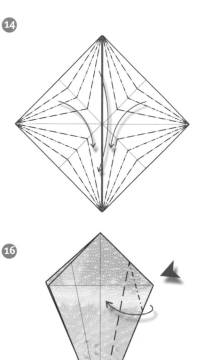

15

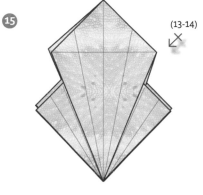

(13-14)

16

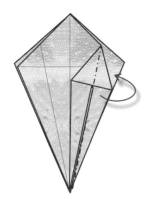

17

18

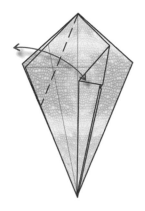

13 Fold the front layer upward. Open out the folded points. The model should look similar to the diagram in step 8.

14 Fold the front layer down. Refold all the creases made previously. When this is complete, the model should fold flat.

15 Repeat steps 13 and 14 on the other side.

16 Lift and fold over one layer. This will cause the top corner to squash and fold flat.

17 Carefully fold the right edge of the front layer behind, as shown.

18 Fold and unfold the top left–hand edge down to align with the middle crease.

common octopus—continued

19 Fold over one layer to the right. This will cause the top triangle to open out. Squash this corner flat.

20 Now fold over one of the layers beneath. Separate the layers, and then flatten and squash the corners.

21 Fold the right and left outer edges of the front layer behind.

22 Fold the front section of the model in half along the vertical line; then fold the right side behind, as shown.

23 Fold the lower layer over along the dotted line, causing the top corner to open out. Now squash it flat.

24 Fold the left–hand edge of the top layer of the model neatly behind.

5

19

20

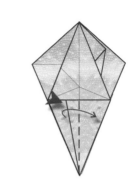

21

22

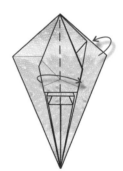

23

24

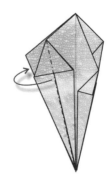

25

26
(19-22)

25 Fold the front layer of the model back over to the left, as indicated.

26 Repeat steps 19 to 22 on the right side. This should mirror the reverse side.

27 Make a reverse fold in all eight points; these will form the tentacles of the octopus. The reverse folds should be exactly in the middle of each point.

28 Now fold the model in half, with four tentacles to the front and four behind. Then fold the top corner behind.

29 Reverse fold all the points up and down to add shape to the tentacles. Open out the top section to give shape to the body. Fold all the legs out and adjust their angles to give the octopus a more realistic shape.

27

28

29

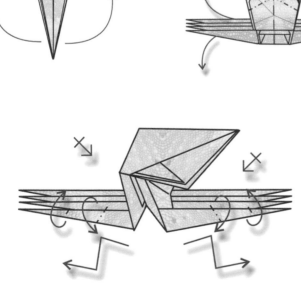

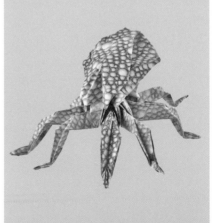

rufous hummingbird

Hummingbirds are among the smallest type of birds, and can hover in midair by rapidly flapping their wings up to eighty times per second. They are known as hummingbirds because of the sound made by their beating wings.

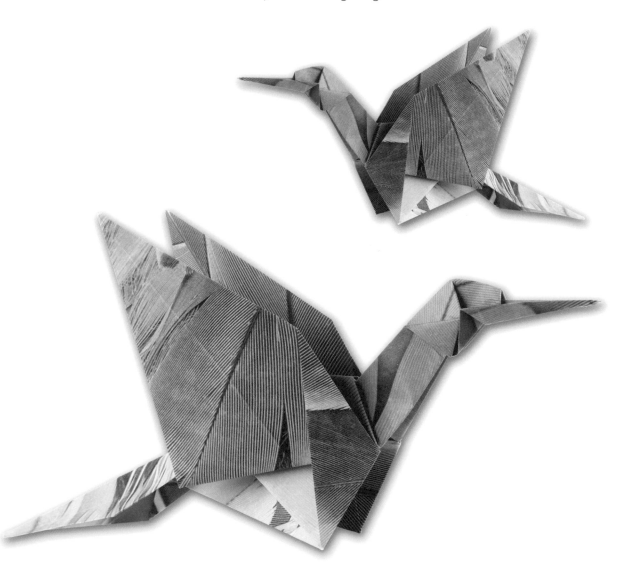

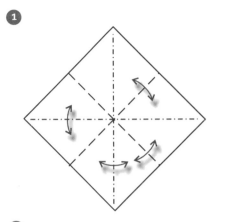

1

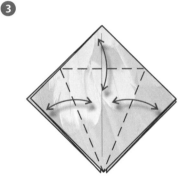

2

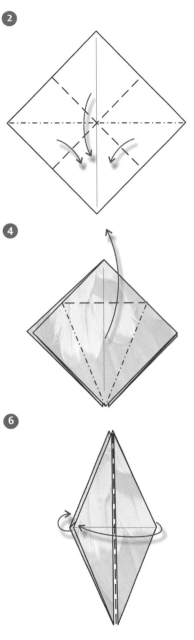

3

4

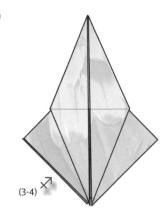

5

(3-4)

6

1 Start with a square piece of paper, colored side down. Fold and unfold in half horizontally, vertically, and diagonally. The diagonal folds should be mountain folds (see page 9).

2 Refold the creases already made to form a preliminary base (see page 13).

3 Fold and unfold the outside edges in toward the center. Fold the top triangle down, then unfold back up.

4 Fold just the top layer up along the horizontal crease that was made in step 3.

5 Repeat steps 3 to 4 on the other side.

6 Fold the right side of the front layer over to the left of the model. Then repeat this process on the other side.

> >

THE AVIARY–RUFOUS HUMMINGBIRD

rufous hummingbird—continued

7 Fold both the outer edges in to align with the middle crease.

8 Reverse fold out the left and right middle points of the model at right angles. These will start to form the wings of the bird.

9 Fold the layers behind the middle points down, then turn the model over.

10 Bring the lower point of the model up by folding it along the horizontal line, as indicated.

11 Fold the model in half along the vertical crease line. Rotate the model 90° clockwise.

12 Create a bird's-foot fold (see page 13) on the front point by folding it down and then back up again.

13 Reverse fold the rear right-hand point of the model—this will start to form the tail.

14 Complete the tail of the hummingbird by folding the edges of the reversed point behind on both sides.

7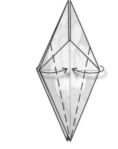

8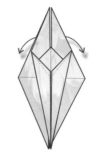

9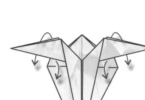

10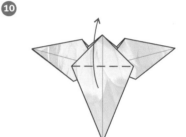

11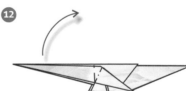

12

13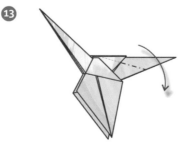

14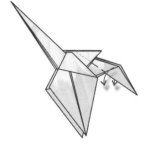

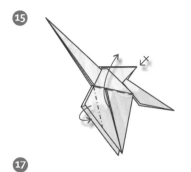

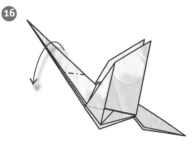

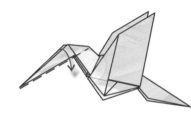

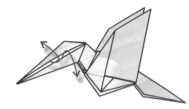

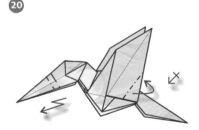

15 Carefully fold the wings up along the folded edge, behind. Repeat the fold on the other side.

16 Reverse fold the forward point of the model to create the characteristic long bill of the hummingbird.

17 Now fold down one edge of the newly formed head and bill.

18 Open out the trapped layers of paper in the head and turn the sides inside out.

19 Fold the bill into and out of the head. Then fold the lower corner of the wing behind. Repeat on the other side.

20 Squeeze the released paper and flatten to shape the head. Repeat behind.

21 Fold the edge of the beak up to narrow it. This will cause the cheek to fold up. Fold in the edge of the body to shape it. Repeat on the other side.

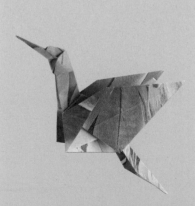

THE AVIARY—RUFOUS HUMMINGBIRD

greater flamingo

When young flamingos hatch, they have a grayish–red plumage. As they grow and become adults, their colors will range from light pink to bright red, depending on their diet.

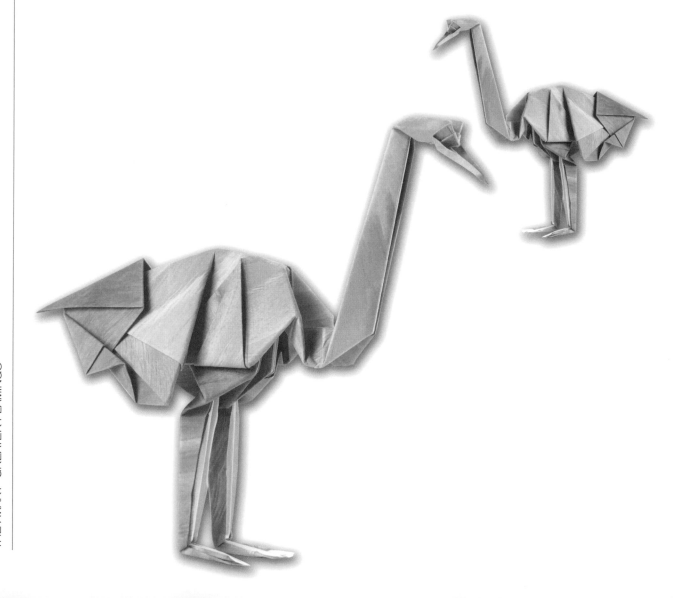

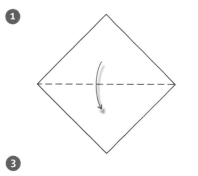

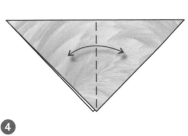

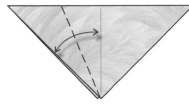

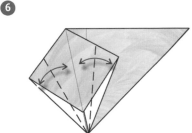

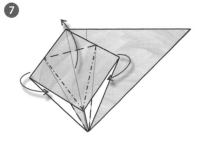

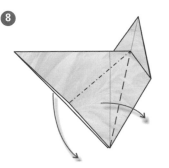

1 Start with a square piece of paper, colored side down. Fold the square in half diagonally.

2 Fold and unfold the paper in half along the dotted line.

3 Fold the left edge of the model in to align with the middle crease made in step 2.

4 Fold the left side over to align the middle crease with the fold made in the previous step.

5 Lift up the point, open out the layers, and squash the point flat.

6 Fold and unfold each of the outer edges of the folded section in to the middle crease.

7 Lift and fold the top section up while reversing the folds made in the previous step. Turn the model over.

8 Repeat the fold made in step 5: lift and fold up the point, open the layers, and squash the point.

> >

greater flamingo—continued

9 Fold and unfold the outer edges of the folded section to the middle crease.

10 Lift and fold the top section up. This will reverse the folds made in the previous step.

11 Fold the top point back down again, as shown. Turn the model over.

12 Make a crease across the points by folding and unfolding both the points of the top layer.

13 Lift and fold the point to align its outer edge with the crease made in the previous step.

14 Bring the point up and and fold it out to the right. Separate the layers and flatten.

15 Halve the width of the point by folding it behind, then fold it over the paper above.

16 Fold the point over where indicated. This will cause a triangular squash fold below.

17 Fold the point back. Repeat steps 13 to 17 on the other side.

18 Fold both the outer edges in to align with the middle crease.

19 Fold the top point down over the body. Fold it back again, then rotate the model. Fold the model in half behind, along its length.

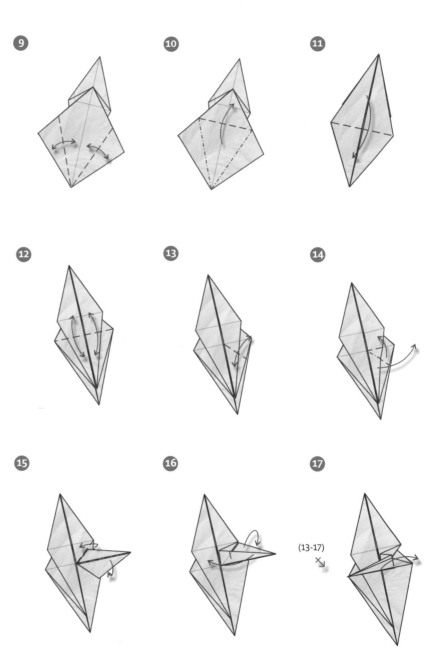

9

10

11

12

13

14

15

16

17

(13-17)

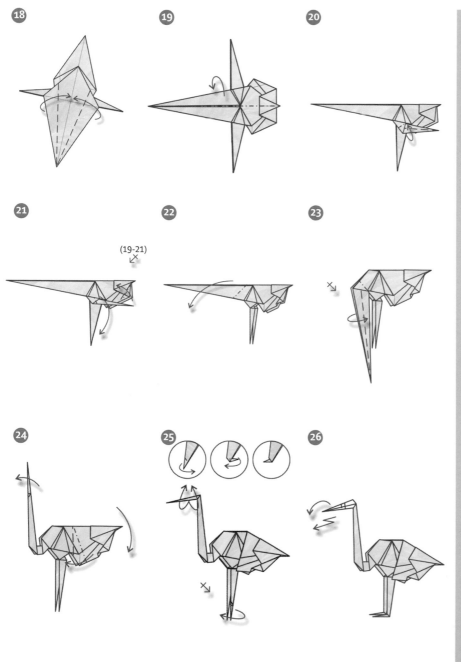

18

19

20

21

(19-21)

22

23

24

25

26

20 Neatly reverse fold the leg. Fold the edge of the point up and into the point on both sides to narrow the leg.

21 Reverse fold the leg, then fold the edge of the rear section over and back again. Repeat steps 19 to 21 on the other side.

22 Make a reverse fold to the front point of the model to start forming the head and neck of the flamingo.

23 Fold the left edge of the point in on both sides to narrow the neck of the flamingo. Repeat the folds on the other side.

24 Reverse fold the point twice to shape the neck. Reverse fold the neck and fold it back again to start making the head. Fold the rear section over the body on both sides.

25 Pull out the trapped paper in the head. Reverse fold the tips of the legs and fold them back to make feet.

26 Zigzag fold the beak into and out of the head. Pinch and curve it to give it shape.

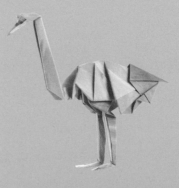

THE AVIARY—GREATER FLAMINGO

toco toucan

The toucan's large beak allows it to reach deep into holes in trees to access food other birds cannot reach; it also helps regulate the toucan's body temperature.

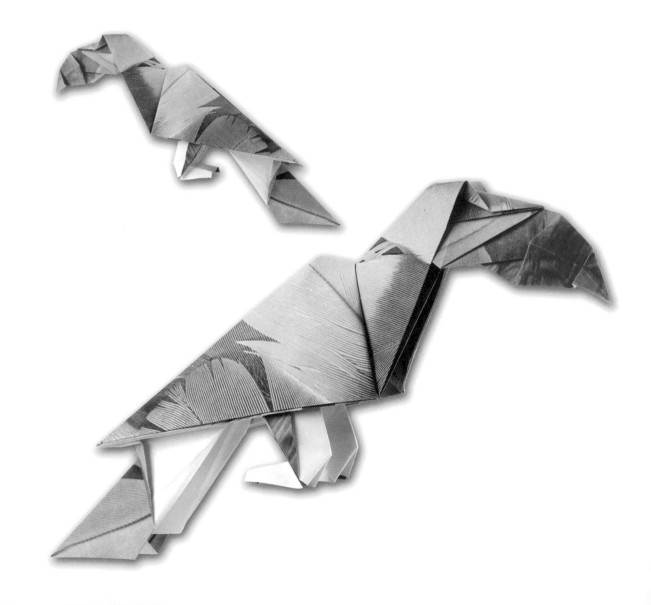

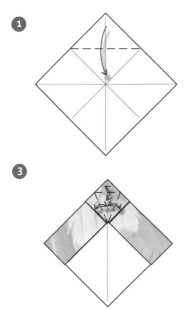

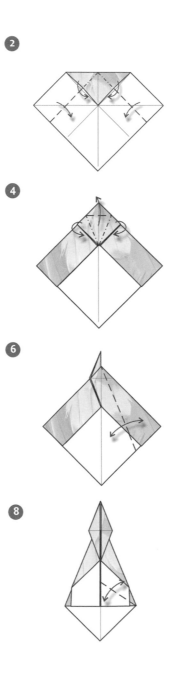

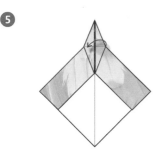

(5-7)

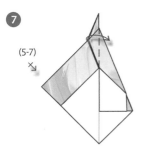

1 Start with a square piece of paper, colored side down. Fold the square in half lengthwise and diagonally. Fold the upper corner to the middle of the paper.

2 Fold and unfold the edges to the middle crease. Then refold the folds previously made. The edges should fold neatly underneath the folded triangle.

3 Concentrating on the top section, fold and unfold the outer edges of the model to the middle crease and the triangular tip.

4 Lift up the top layer using the folds made in the previous step.

5 Fold the right-hand edge of the top section over to the left.

6 Fold and unfold the outer right-hand edge to the middle crease.

7 Reverse fold the right edge into the model along the crease made in the previous step. Fold the layer back. Then repeat steps 5 to 7 on the other side.

8 Fold and unfold the lower right-hand edge to the outer edge.

THE AVIARY—TOCO TOUCAN

> >

toco toucan—continued

9 Reverse the edge into the model along the creases made in the previous step.

10 To start making the feet, fold and unfold the lower point on the right–hand side of the model.

11 Fold the point midway between the edge and the crease made in the previous step.

12 Fold out the inner folded edge to align with the outer edge of the model.

13 Lift and fold the edge that will create one of the feet out along the crease made in step 11, and refold the fold made in step 12. Repeat steps 11 to 13 on the other side.

14 Make a fold in the top point that is level with the folded tip in the layer beneath.

15 Open out the upper section of the paper. Fold the inner edges out to the folded edge and refold the tip. Turn the model over.

16 Fold in the corners of the top section as indicated, then fold the tip of the triangular point behind.

17 Fold and unfold the model along the dotted line.

18 Pull out the paper in the upper section while folding the model in half.

19 Fold the top section into the model and reverse it out again along the crease made in step 16. This is a crimp fold (see page 14).

9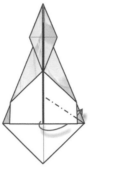

10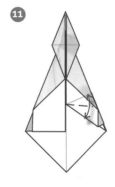

11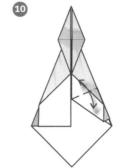

12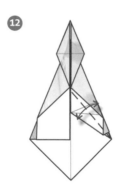

13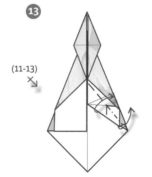

(11-13)

14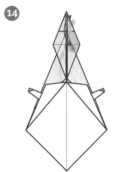

15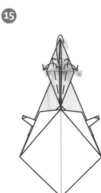

16

17

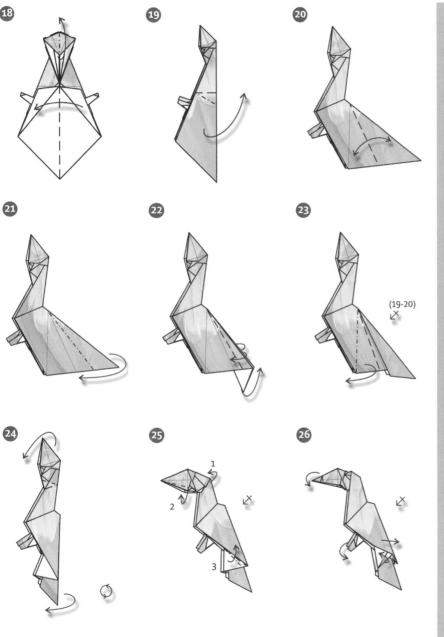

(19-20)

20 Fold and unfold the right edge along the solid crease line, then fold the outer edge to the crease that was just made.

21 Fold the right edge to the crease made in the previous step. Then reverse the outer edge into the model.

22 Fold the outer edge to the crease made in step 20 on both sides. Then reverse fold out the folded edge.

23 Now fold the section into the model along the fold made in step 19. Then fold it out again along the fold made in step 20.

24 Make a crimp fold to the head to fold it down. Move the tail slightly away from the outer edge. Rotate the model counterclockwise slightly.

25 Lift and fold up the front layer of the paper trapped behind the head (1). Fold in the edges of the beak (2). Fold up the paper on the edge of the tail (3). Repeat on the other side.

26 Finally, fold the edge of the lower triangle. Lift the wings to cover it. Crimp fold the beak and reverse fold the legs to make feet. Repeat on the other side.

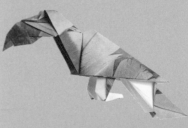

THE AVIARY—TOCO TOUCAN

diamondback rattlesnake

Rattlesnakes lie in wait for their prey or hunt for it in holes. They detect their prey using a heat–sensing pit behind each nostril and kill quickly, with a venomous bite.

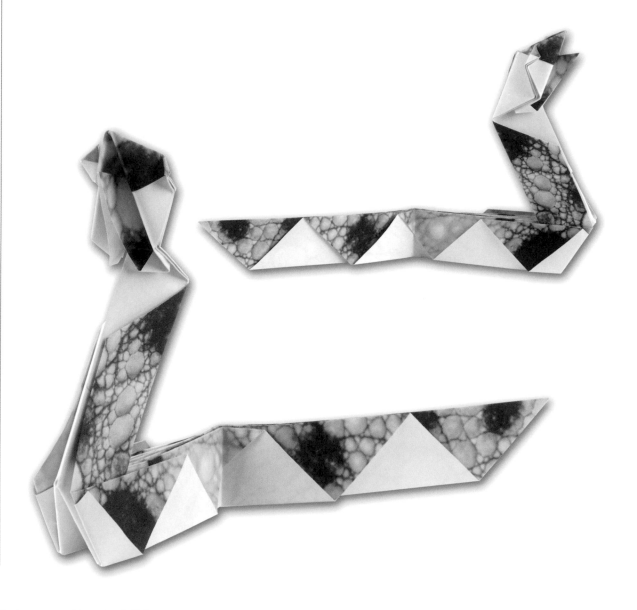

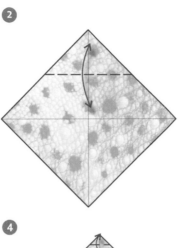

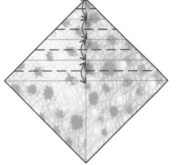

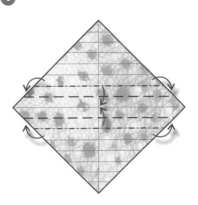

1 Start with a square piece of paper, colored side up. Fold and unfold the square diagonally on both sides.

2 Fold and unfold the top corner to the middle of the square.

3 Make another fold between the creases, then unfold. This divides the upper section of the paper into four sections.

4 Continue to make folds between the creases, dividing the upper section into eight sections.

5 Repeat steps 2 to 4 on the lower section of the paper.

6 Fold the paper toward the middle along the creases made in the previous steps.

THE REPTILE HOUSE—DIAMONDBACK RATTLESNAKE

> >

diamondback rattlesnake—continued

7 Fold the upper layer into the middle and back again. Repeat this process with the other folds.

8 Fold the outer corner in where indicated. Use the the scale to determine the proportion of the fold.

9 Fold the left end of the model behind. This will form the head.

10 Continuing to work on the left side, fold over two triangles on the folded end.

11 Narrow the snake's body by folding it in half behind along its length, as shown.

12 Fold and unfold the left side. Reverse fold the model and turn the front section inside out, where indicated.

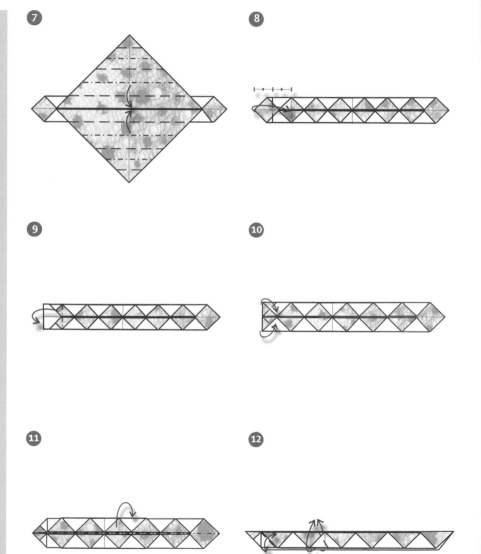

13

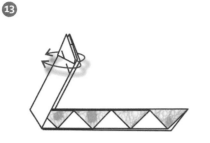

14

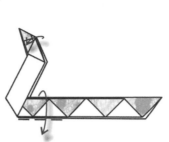

13 Reverse fold the head of the snake along the crease that was made in step 12. Turn the tip inside out.

14 Fold over a small tip of the triangle on the head to make an eye. Fold out one layer of paper from behind the reversed section.

15 Fold back the released paper. Repeat steps 12 to 14 behind.

16 Make a fold in the snake's tail. Carefully pull open the mouth slightly.

15

(12-14)

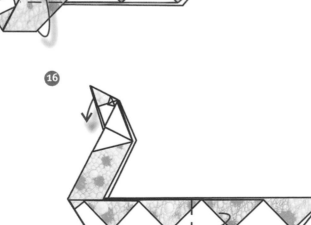

16

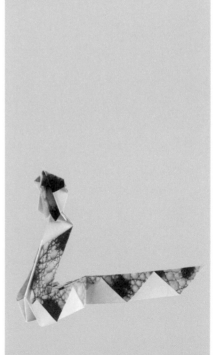

common chameleon

Chameleons feed by rapidly shooting out their long tongue to capture prey. Their tongue can be up to two times the length of their body.

9

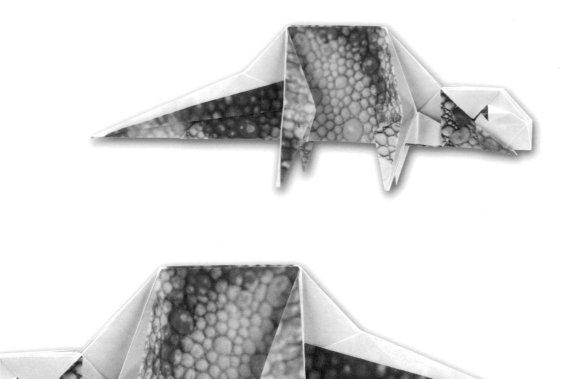

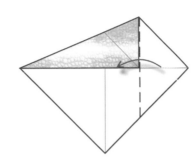

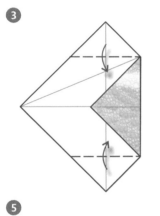

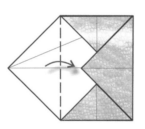

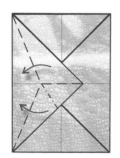

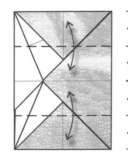

1 Start with a square piece of paper, colored side down. Fold and unfold the model in half diagonally in both directions. Fold the top left edge down to align with the middle crease.

2 Lift the right–hand point and fold it over the edge you just folded.

3 Unfold the fold you made in step 1, and fold the upper and lower corners in to touch the previously folded right–hand corner.

4 Bring the left–hand corner back in to touch the upper and lower folded corners, and overlap the right–hand corner.

5 Fold the two edges of the corner in to the left edge. Fold the tip to point downward.

6 Make two horizontal creases by folding and unfolding the upper and lower edges to the middle of the model.

>>

common chameleon—continued

9

7 Fold the tips of the upper and lower corners at the crease made by the previous step, so that the top corner is behind and the lower corner is in front.

8 Neatly fold the paper in half along the horizontal crease.

9 Fold the top edge down. At the same time, fold in both sides along the diagonal folds. Repeat on the other side.

10 Turn down the front layer of the model and crease along the dotted line.

11 Pull out the tip of the model. Open out the layers beneath and squash them flat.

12 Fold the lower section up along the dotted line, while simultaneously reverse folding out the right–hand point.

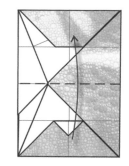

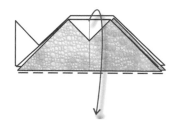

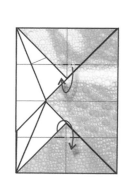

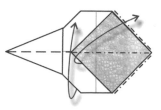

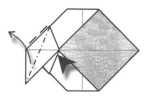

13

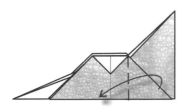

14

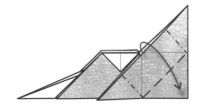

15

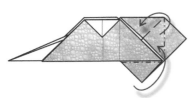

16

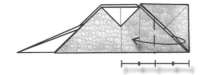

17

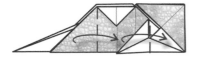

18

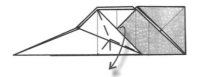

13 Continue to shape the body: fold over the triangle in the front section where indicated.

14 Bring the middle of the triangle down to touch the lower corner. This will cause the sides of the point to fold in.

15 Lift the lower triangle and fold it up beneath the top layer. Then fold the upper section over to align the folded edges.

16 The right side of the model will form the front legs and the head. Fold over the rear triangle, causing the paper in the layer beneath to squash and fold flat.

17 Start forming the legs. Fold back the triangle on the left. This will cause a squash fold, as in the previous step. Fold back the triangle on the right as well.

18 Bring the edges of the triangles together and fold them, causing the tips to point downward. These will become two of the legs.

THE REPTILE HOUSE—COMMON CHAMELEON

common chameleon—continued

19 Reverse fold the point inside itself to start forming the front legs.

20 To refine the shape of the front legs, fold the edges in to narrow them.

21 To finish the front legs, fold the lower edge of each leg into the model. Then repeat steps 13 to 21 on the reverse side of the model to complete the back legs.

22 Turn the triangle on the right inside out and fold it to the right.

23 Bring the front layer down. This will cause the front section to open up. Then flatten it.

24 Refold the front layer back, but leave the front section flattened.

25 Fold the outer point (1) over. At the same time, fold out the top layer (2) to the left and flatten.

26 On the right side, fold over the outer layer. This will turn the point inside out. Fold up the triangle at the top. Now turn the model over, left to right.

19

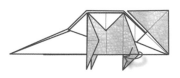

20

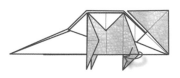

21

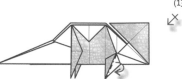

22

(13-21)

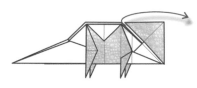

23

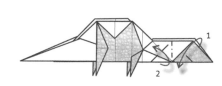

24

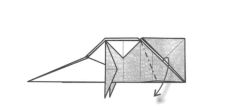

25

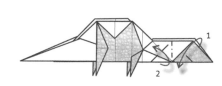

26

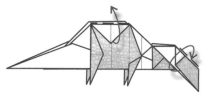

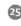

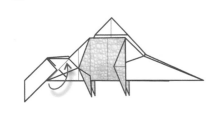

27

28

29

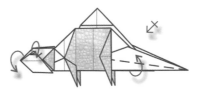

30

31

32

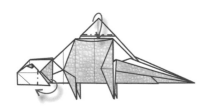

33

27 To form the head, reverse fold out the trapped paper as indicated.

28 As you fold over the end of the left side, open it out and flatten the tip.

29 Bring the flattened point of the head back together, as shown.

30 Reverse fold the point, turning it inside out back over the head.

31 Fold out the trapped paper on the lower section of the head. Repeat behind.

32 Continue to form the head: fold down the middle layer, fold up a small corner, and squash it to create an eye. Thin down the tail section by folding the top layer up as indicated. Repeat behind.

33 Reverse fold the front tip, turning it inside out, to make a mouth. Then tuck the top triangle into the pocket in the layer in front.

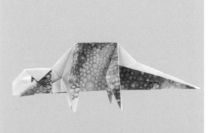

THE REPTILE HOUSE—COMMON CHAMELEON

horned lizard

Most lizards communicate through body language, using specific postures, gestures, and movements to define territory, resolve disputes, and entice mates.

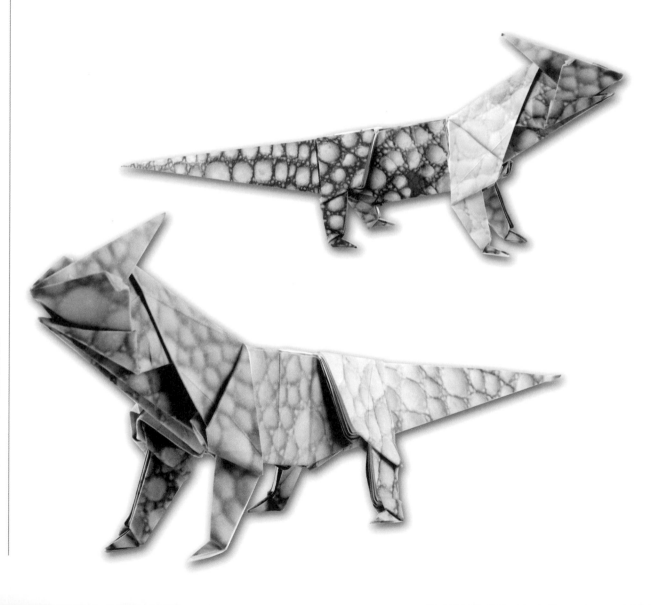

1

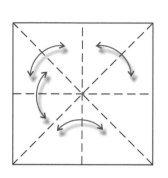

2

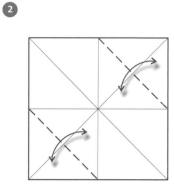

3

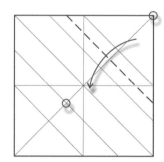

4

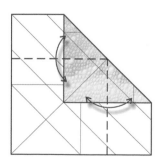

5

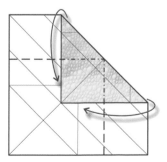

6

1 Start with a square piece of paper, colored side down. Fold and unfold in half horizontally, vertically, and diagonally.

2 Fold and unfold the bottom left and top right corners toward the middle.

3 Make additional folds between the creases made in the previous step and the middle crease.

4 Fold the corner over to touch the crease made in the previous step, indicated by the red circle.

5 Fold and unfold the edges above and to the right over the folded triangle, as shown.

6 Reverse the edges underneath the folded triangle by refolding the crease made in the previous step.

> >

horned lizard—continued

7 Fold the edges of the top right section to the middle. Fold over the triangle formed by their edges, then unfold.

8 Fold over the top layer along the crease made in the previous step. Now unfold the model back out to a square.

9 Repeat steps 4 to 8 on the opposite corner of the sheet of paper.

10 Refold the paper where indicated. Then refold steps 4 to 8 along the crease lines made in the previous steps.

11 Fold and unfold the outer edge of the model.

12 Make the folds marked (a) on both sides and then open out the paper behind, along the folds made in the previous step. Fold it flat.

7

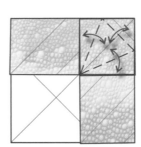

8

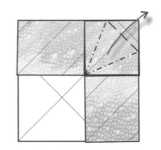

9

10

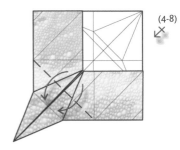

(4-8)

11

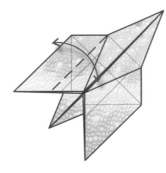

12

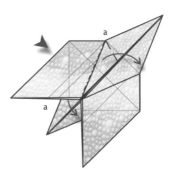

13

14

13 Fold the corner back over, and fold both sides in where indicated by the arrows.

14 Fold the top left corner back over along the dotted line.

15 Fold the tip of the triangle behind, into the model.

16 Continue on the top layer: fold and unfold along the middle of the points.

17 Bring the outer edge in and refold along the creases made in the previous step.

18 Repeat steps 12 to 17 on the opposite side. Then rotate the model 45°.

15

16

17

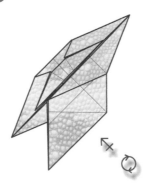

18

THE REPTILE HOUSE–HORNED LIZARD

horned lizard—continued

19 Lift up and fold the two right–hand triangles over to the left.

20 Make folds at (a) and then fold out both of the points to start forming the rear legs.

21 Turn the model over.

22 On the right side, fold over the edges of the model between the tip and the middle crease on the upper and lower sides.

23 On the left side, fold over both edges of the model to the middle crease.

24 Start to refine the body. Fold the edges of the right–side point in, from the tip to the edge of the folded middle section. Now fold over the edges of the middle section.

25 Carefully fold the body of the lizard in half along its length.

26 To form the front legs, fold the front triangles down where indicated. Repeat the process on the other side.

19
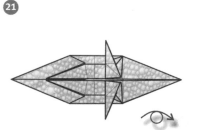

20
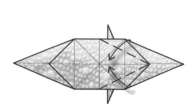

21
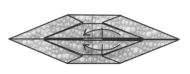

22
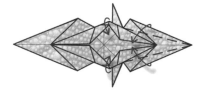

23
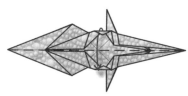

24
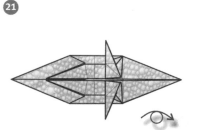

25

26
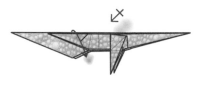

27
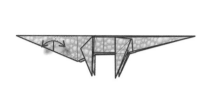

28
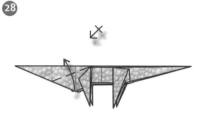

29
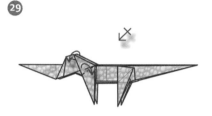

30
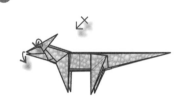

31
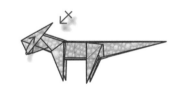

32
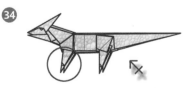

33

34
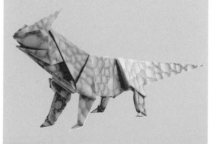

27 To make the head, fold and unfold the front point at the tip of the folded triangle in the layer beneath.

28 Lift the layer up and fold out the trapped paper beneath both front legs. Repeat on the other side.

29 Continue to form the head. Fold the top layer over and flatten the paper. Repeat the process on the other side.

30 To create the horns reverse fold the point back over the fold made in the previous step.

31 Add shape to the head: fold up the corner of the head on both sides.

32 To make the eyes, fold over the tip of the folded triangle, then repeat behind. Open the mouth down slightly.

33 Refine the shape of the legs by folding them back and out again in a crimp fold, to slant the legs forward. Repeat on the other side.

34 Reverse fold and fold back the tips of each leg to make feet.

THE REPTILE HOUSE—HORNED LIZARD

green frog

Most frogs live in freshwater and on dry land, but the adults of some species have adapted to living underground or in trees, and some have even learned to glide.

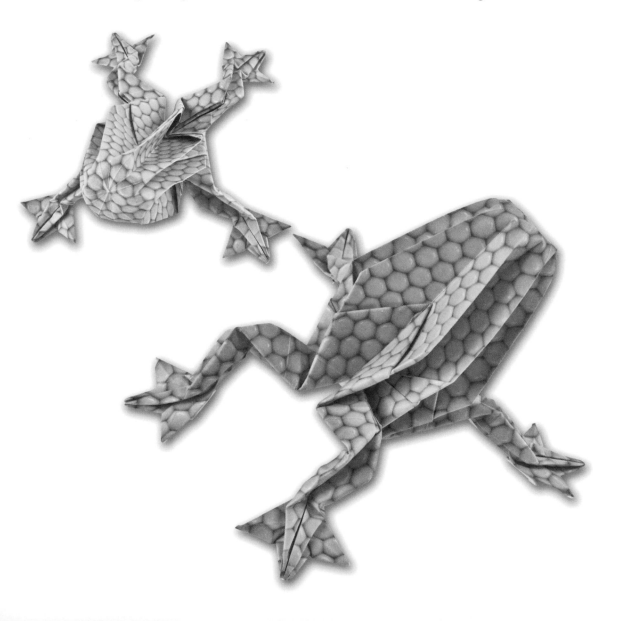

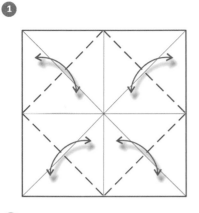
1

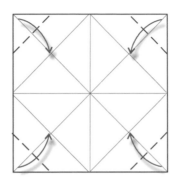
2

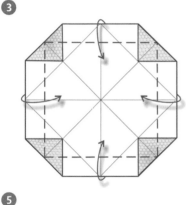
3

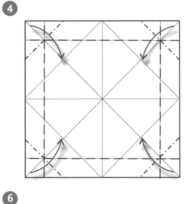
4

5

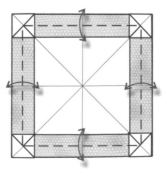
6

1 Start with a square piece of paper, colored side down. Fold and unfold in half vertically, horizontally, and diagonally. Fold and unfold the four corners into the middle of the paper.

2 Bring the four corners down to the creases made previously.

3 Fold all four edges in to the square along the dotted lines. Now unfold the model back into a square.

4 Fold in the edges and corners simultaneously. This will form a shape similar to a preliminary base on each corner. Fold out again.

5 Fold over the top layer of each diamond on each of the four corners.

6 Fold the edges of the folded sections out to each edge of the model.

> >

green frog—continued

7 Fold over the triangles as indicated on all four corners of the model.

8 On the upper and lower sides, fold up the paper edge to meet the edge of the model.

9 Refold the triangles that were folded over in step 8 back over.

10 Fold out the left and right edges of the paper to meet the outer edges of the model.

11 Fold over the triangles at each corner of the model.

12 Refold the model together along all the creases formed in step 1. This will create a more complex preliminary base.

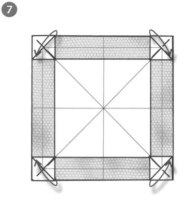

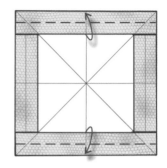

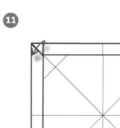

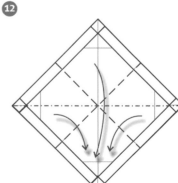

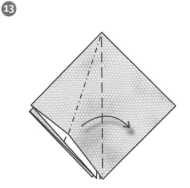

13

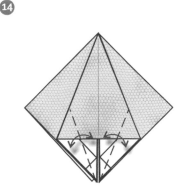

14

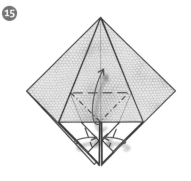

15

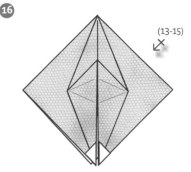

16

(13-15)

17

a

b

18 a

c

b

13 Lift up one corner, separate the layers, and squash the point evenly.

14 On the top layer, fold and unfold the outer edges in to the middle.

15 Fold the top layer up, and refold the creases made in the previous step.

16 Repeat steps 13 to 15 on the other three corners of the model.

17 In these steps you will begin to make the feet.
a Fold the edges of the point over at the front and on the reverse of the foot.
b Pull the trapped paper out to align the paper edge to the folded edge. Repeat on the reverse side of the foot.

18 Create the webbing on the frog's feet.
a Fold over the top layer from left to right.
b Fold the lower edges in to the middle. This will cause some squash folds in the layers of paper beneath.
c Bring the layers back together. Repeat steps 17 and 18 on the other three points.

green frog—continued

19 Fold the top right–hand layer of the model over to the left.

20 Fold the left and right outer edges in to the middle of the frog's body.

21 Fold the top layer of the model back over from left to right.

22 Repeat steps 19 to 21 on the other three points of the model.

23 To make the front legs, reverse fold the points in the front layer of the model up.

24 To form the rear legs, reverse fold out the points in the direction of the arrows.

19

20

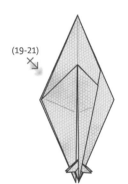

21

22

(19-21)

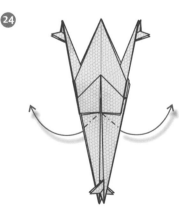

23

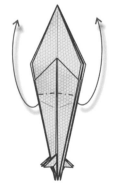

24

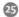 **25**

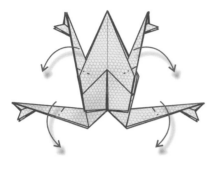

26

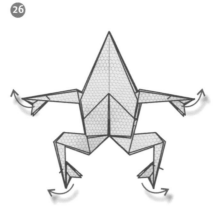

27

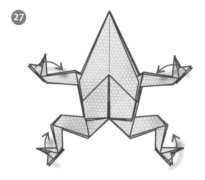

28

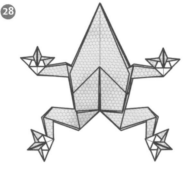

29

25 To shape the legs of the frog, reverse fold all four points .

26 To make the feet, fold the tips of the legs over as shown.

27 Open out all the feet you made in steps 17 and 18 and flatten them.

28 Turn the model over.

29 Inflate the model by blowing gently into the body where indicated and pulling apart the front layers to give the body shape.

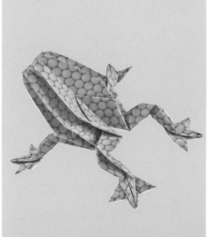

THE REPTILE HOUSE—GREEN FROG

masai giraffe

Adult giraffes are the tallest terrestial mammal, standing eighteen to twenty feet tall, with males taller than females. They have a twenty–inch tongue, which they use for grasping the highest leaves on the branches of the trees they feed on.

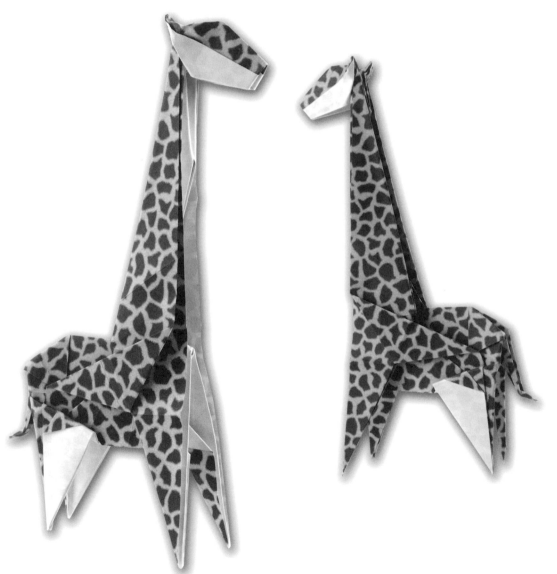

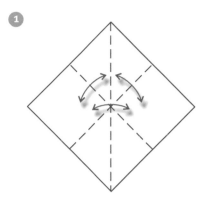

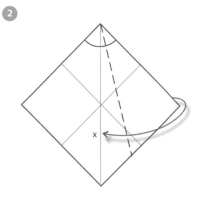

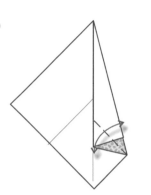

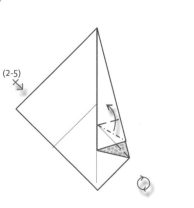

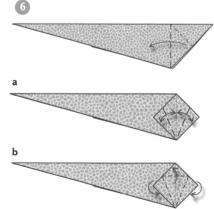

1 Start with a square piece of paper, colored side down. Fold and unfold in half horizontally, vertically, and diagonally.

2 Fold the right–hand corner in to the middle crease, marked X. This is a reference point.

3 Fold the corner again, bringing it back to align with the two folded edges.

4 Fold the inner corner to the right along the indicated line.

5 Fold the corner up and repeat steps 2 to 5 on the other side. Rotate the model 90° counterclockwise.

6 Fold the model in half lengthwise. Fold the right corner up, separate the layers, and squash them. This is similar to the process for making a preliminary base.
6a Fold and unfold the left and right edges to the middle.
6b Fold the front layer along the folds made in the previous step. This is similar to the process for making a bird base (see page 14).

THE MAMMAL HOUSE—MASAI GIRAFFE

> >

masai giraffe—continued

7 Open out the model and flatten the folded section on the right–hand side.

8 Fold the right–hand section of the model behind as indicated.

9 Fold the model in half behind. As you do so, fold the right–side triangle into the model. Then rotate the model.

10 Start forming the neck of the giraffe: fold over the outer lower layers of the point on both sides, thus folding the top point backward.

11 Fold the triangles out as indicated, then repeat the process on the other side.

12 Reverse fold the point over itself by valley folding (see page 9) the outer layers in front and behind. This will cause the paper in the layer beneath to open out.

11

7
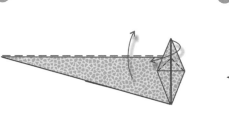

8

9
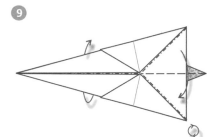

10
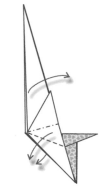

11
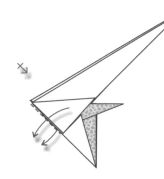
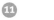

12
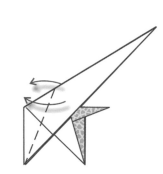

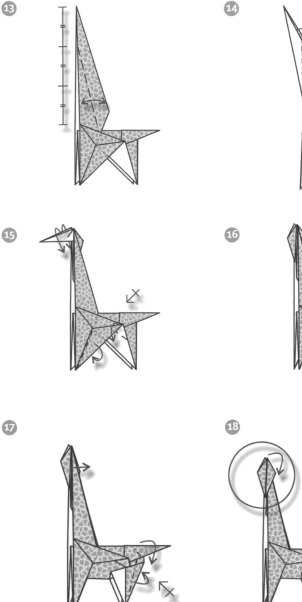

13 Form the neck of the giraffe by folding and unfolding where indicated. The fold should extend to about two–thirds of the way up the neck; use the scale to determine the proportions of the fold.

14 Make a reverse fold in the neck along the folds made in step 13. Reverse fold the neck into the model along the edge of the paper above.

15 Reverse fold the head back again, leaving out just a small section. Turn the head inside out. In the lower section of the model, fold the outer edge of the front leg behind.

16 Sink the triangle behind the head. Then fold the back legs up and back again, as indicated. Repeat the process on the other side.

17 Refine the rear legs by folding in the outer edges. Reverse fold the tail. Pull out the trapped paper on both sides of the head.

18 To finish the head, fold it up and shape the ears; fold in the nose. Finally, narrow the tail.

THE MAMMAL HOUSE—MASAI GIRAFFE

common zebra

Each zebra's stripes are as unique as a human's fingerprints; no two are exactly the same. Each of the three species of zebra—the plains zebra, the Grévy's zebra, and the mountain zebra—has its own type of pattern.

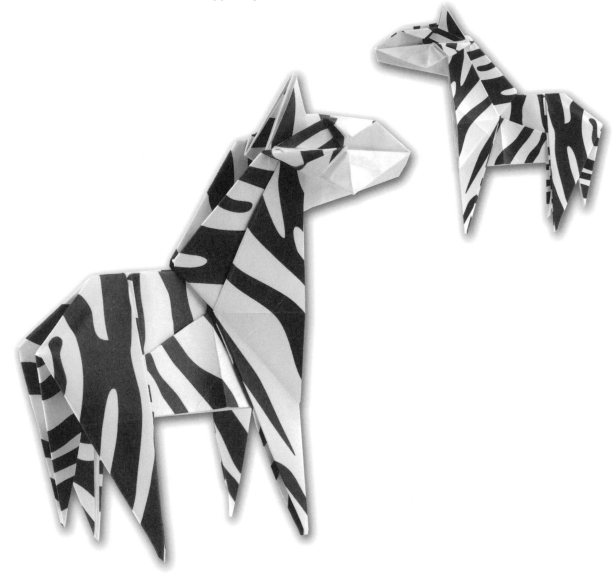

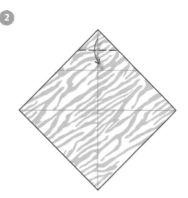

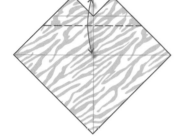

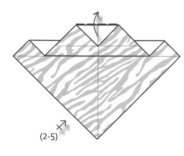

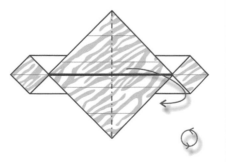

1 Start with a square piece of paper, colored side up. Fold and unfold diagonally in both directions. Then fold and unfold the top corner of the paper to the middle of the square.

2 Lift the upper corner up and fold it in to touch the crease made in the previous step.

3 Fold and unfold the top edge of the model to the middle line.

4 Fold the top section down and up again between the crease made in the previous step and the middle line.

5 Bring the tip back up. Repeat steps 2 to 5 on the lower section.

6 Fold the model in half behind. Then rotate the model 90° counterclockwise.

common zebra—continued

7 Start forming the shapes that will become the legs. Fold the left-hand corner over to the right and squash it.

8 Fold and unfold the left and right edges to the middle of the diamond.

9 Form a bird–base shape by folding the top layer up along the horizontal crease.

10 Fold the point down. Then repeat steps 8 to 10 on the other side. These two shapes will be the front legs.

11 Carefully open out and unfold the model back to step 6.

12 Refold along the creases previously made to get a stretched bird–base shape.

7

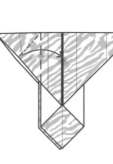

8

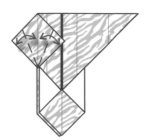

9

10

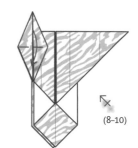

(8–10)

11

12

13

14

13 Start to form the rear legs: fold and unfold along the dotted line where indicated.

14 Fold up the lower section of the model and then open it out.

15 Fold the corner back down along the dotted line, as indicated.

16 Start work on the head section of the zebra: fold and unfold the edge of the top corner.

17 Bring the corner down and the edge back. Fold the paper underneath out while folding down the upper point.

18 Fold the corner back over from right to left.

15

16

17

18

common zebra—continued

19 Pull out and fold the paper trapped beneath the folded edge.

20 Fold up and squash.

21 Continue working on the head section: fold the lower edge up in the direction of the arrow.

22 Lift and fold up the two upper corners in the top section.

23 Keeping the model flat, carefully fold the zebra in half along the middle of the front legs .

24 Fold the edges of the top layer together and fold it over to the left. Now turn the model over.

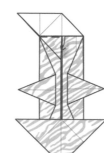

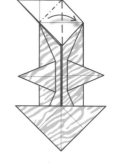

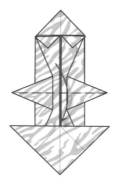

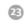

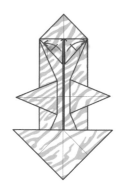

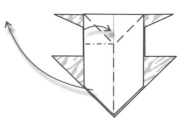

25

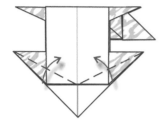

26

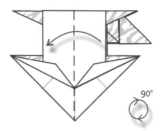

\circlearrowright 90°

27

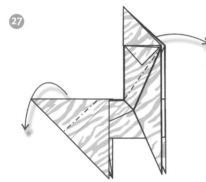

28

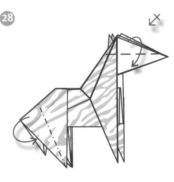

29

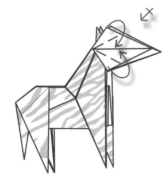

30

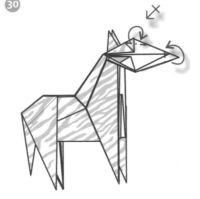

25 Fold up the two lower corners of the middle section of the model.

26 Fold the zebra in half along the dotted line and then rotate the model 90° clockwise.

27 Make reverse folds on the head and tail of the zebra.

28 Fold in half the front layer of the triangle that forms the head. Narrow the legs and tail. Repeat on the other side.

29 Fold in the upper and lower edges of the head, then repeat on the other side.

30 For the final shaping of the head, fold in the upper corners and the nose, and then repeat the folds on the other side.

mountain gorilla

Gorillas are mostly vegetarian; their diet is composed of leaves, shoots, and stems. They also eat small amounts of wood, roots, flowers, and fruit, and occasionally larvae, snails, and ants.

4

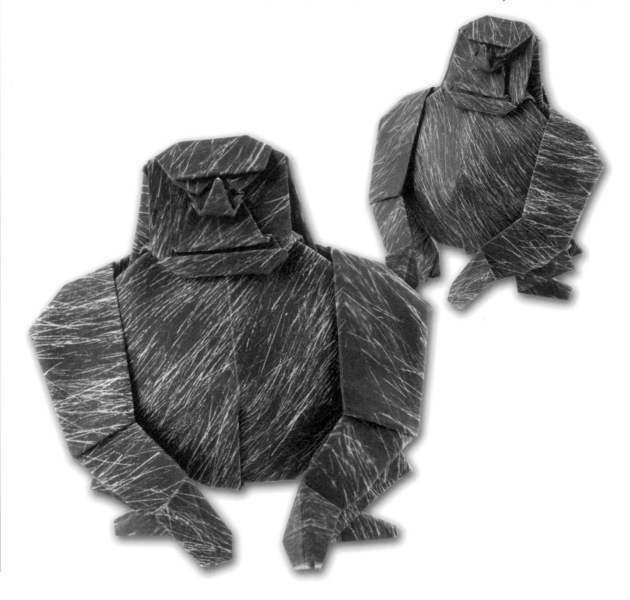

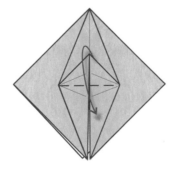

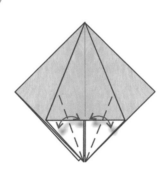

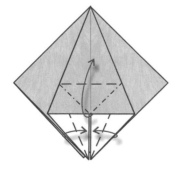

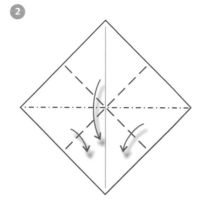

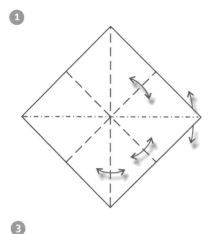

1 Start with a square piece of paper, colored side down. Fold and unfold the square in half lengthwise. Fold and unfold the diagonals behind (make the diagonal folds mountain folds).

2 Fold all the corners over to meet the bottom corner. This is a preliminary base (see page 13).

3 Lift up and and squash one of the corners of the model.

4 Fold and unfold the left and right edges of the top layer to the middle.

5 Gently pull up the lower edge and refold the folds from the previous step.

6 Fold the upper point of the front layer down, as indicated.

THE MAMMAL HOUSE—MOUNTAIN GORILLA

> >

mountain gorilla—continued

7 Repeat steps 3 to 6 on the three other corners of the model.

8 Fold the top front corner behind and into the model. Repeat on the right and left sides, but leave the corner behind pointing downward.

9 To form the arms, fold the two points up. The folds shown are on the layer beneath.

10 Reverse fold up the lower left and right points along the dotted lines. These will be the legs of the gorilla.

11 Make reverse folds on both of the legs so that they point downward.

12 To create the feet of the gorilla, make a reverse fold at the end of each leg.

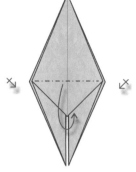

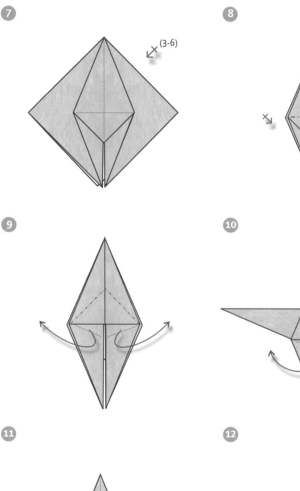

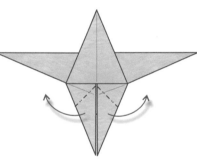

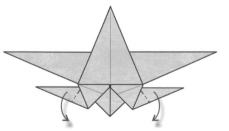

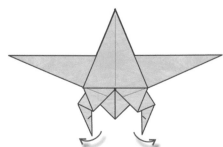

13

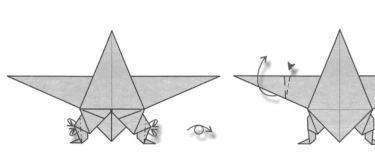

14

15

16

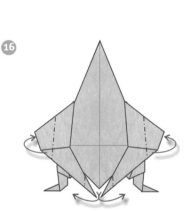

17

18

13 Narrow the legs slightly by folding the edges behind. Then turn the gorilla over.

14 Fold up the left arm by folding the point into itself (a bird's-foot fold—see page 13). Repeat on the other arm.

15 Fold down the left and right arms in the direction of the arrows.

16 The arms need to be thinner, so fold their edges behind. Then reverse fold the tips to start forming the hands.

17 To give the hands more shape, fold over the edges of the points.

18 Finally, fold over the tips of the hands and feet. They are now complete. Fold over the top section to start on the head.

mountain gorilla—continued

19 Fold and unfold the point level with the middle crease on the layer beneath.

20 Use the scale shown to determine the proportions of the folds. Fold and unfold the folded point between the crease made in the previous step and the top edge of the model.

21 Holding the lower layer down, fold up the top layers of the folded point and open out the paper in the point.

22 Pinch the point to the fold made in step 19 and flatten the paper beneath.

23 Now make the gorilla's nose: carefully fold the point up and down.

24 To give the gorilla a brow, pinch the layer to make an edge, and then fold it down.

19
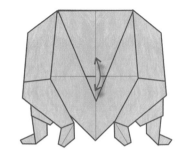

20
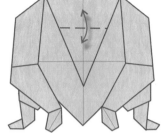

21
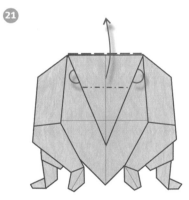

22
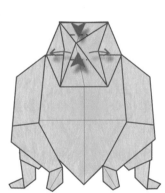

23
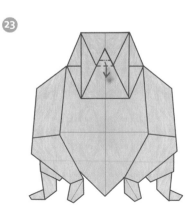

24
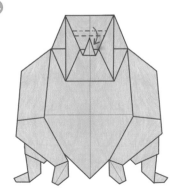

 25

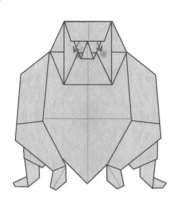

26

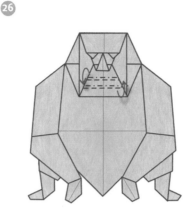

27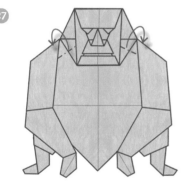

28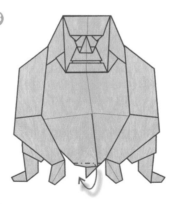

29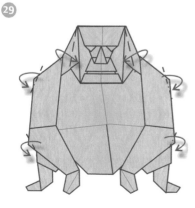

30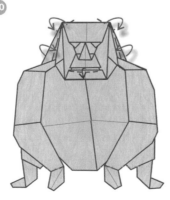

25 Create the gorilla's eyes by folding out two triangles beneath the folded edge.

26 Using a technique similar to that used in step 24, pinch the top layer of the lower face and fold it over to make the gorilla's lips.

27 Refine the shape of the head: fold the top corners of the middle section behind and into the model.

28 Make a fold in the middle of the lower section to make the body more round. Fold the middle of the body behind to lock the fold made in the previous step.

29 Fold the paper in the neck over. Then fold the corners of the arms behind to give the arms a rounder shape. Fold the corners at the shoulders over.

30 Fold the paper at the side of the head into the model, then fold the corners of the head behind to give it a rounder appearance. Finally, open the mouth slightly.

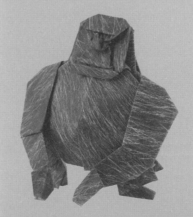

THE MAMMAL HOUSE—MOUNTAIN GORILLA

african elephant

Elephants are the largest living mammals. They are famed for their memory and intelligence, which are thought to be comparable to those of dolphins.

13

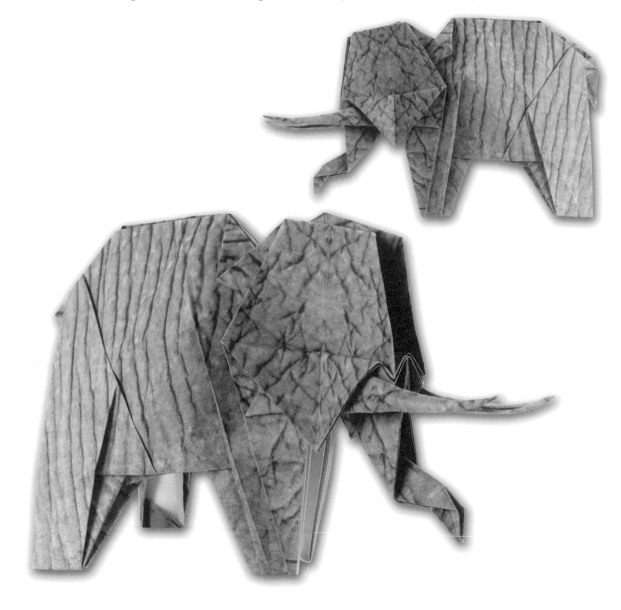

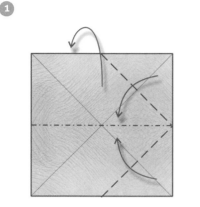

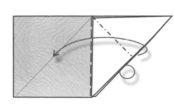

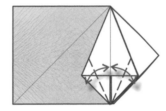

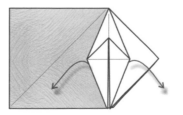

1 Start with a square piece of paper, colored side up. Fold and unfold the square in both directions diagonally. Fold the corners to the middle. Then fold the model in half behind.

2 Lift up the top edge of the right–hand corner, then raise and squash the point.

3 Repeat this process in the other direction: raise the point up to the right and then squash.

4 On the layer you have just created, fold and unfold the left and right edges to align with the middle crease.

5 Fold the edge up and reverse fold the edges together. This is the same method that was used to create the base of the frog on page 69.

6 Now unfold the model, leaving the folded corner intact.

> >

THE MAMMAL HOUSE–AFRICAN ELEPHANT

african elephant—continued

7 Refold the folds where indicated. This will create what is called a blintz frog base.

8 Raise and squash the point to the right, as directed by the arrow.

9 Lift and fold the squashed point up to make a bird base (see page 14).

10 Next, fold the top corner down. Then repeat steps 4 to 10 on the other side.

11 Fold the left edge over. Repeat the fold on the other side.

12 Bring the top edge down and fold and unfold it over to the middle. Make a sink fold (see page 15) along the crease you just made.

7

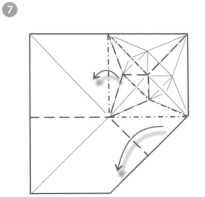

8

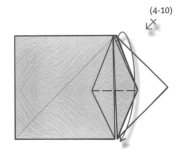

9

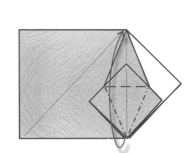

10

(4-10)

11

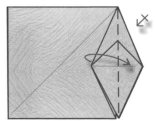

12

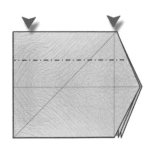

13

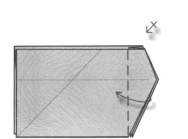

14

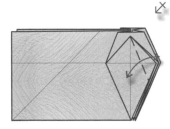

15

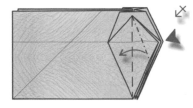

16

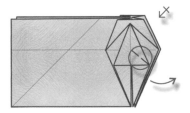

17

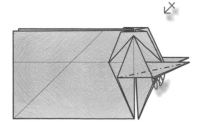

18

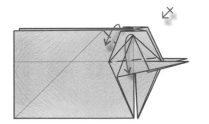

13 This side of the model will become the elephant's head. Fold the edge back over. Repeat on the other side.

14 Fold and unfold the right-hand edge to the middle. Repeat on the other side.

15 Fold up the front corner and squash it along the folds made in step 14. Repeat on the other side.

16 Reverse fold up the point to create one of the elephant's tusks. Repeat on the other side.

17 Narrow the tusks: fold the edges of the folded points behind. Repeat on the other side.

18 Start shaping the head: fold the triangle down, then fold down a triangle at the rear of the head. Repeat on the other side.

african elephant—continued

19 Now work on shaping the rear of the elephant: fold and unfold the left side corner to the crease along the middle of the body.

20 Fold the rear edge behind, and then reverse the fold made in the previous step.

21 Bring the lower back corner up and fold it to the head of the model.

22 Fold the corner back down again. The outer side should be perpendicular to the top side of the elephant's body.

23 Start to form one of the rear legs: fold the paper into the model, then repeat steps 19 to 25 behind.

24 To create the elephant's tail, fold the top left edges of the model behind and inside.

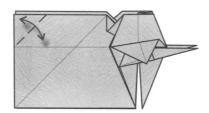

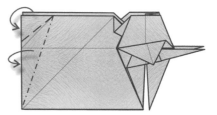

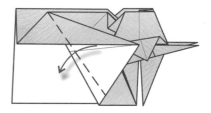

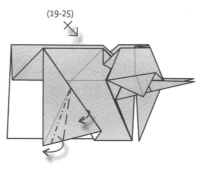

(19-25)

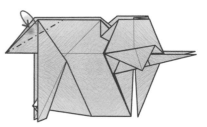

25

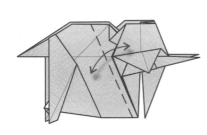

26

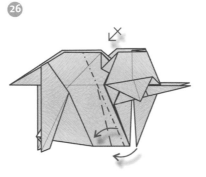

27

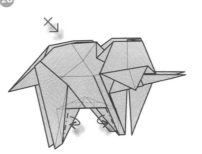

28

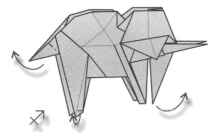

29

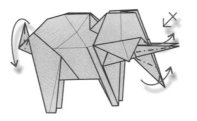

30

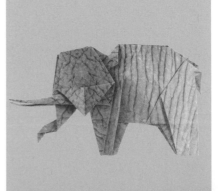

25 Crease the whole model. This fold should be parallel to the edge of the folds in the front leg.

26 Give some shape to the elephant's body by folding the body along the dotted lines to bring the front and back together.

27 Narrow the body by folding the lower edge up and into the model. Repeat on the other side.

28 Make the legs narrower by folding the edges under. Note that the diagram shows the layer of paper underneath being folded.

29 Crimp fold the trunk and reverse fold the tail. Then fold up a small part of the back leg. Repeat on the other side.

30 Fold the trunk up and the tail down, and then give a slight curve to the tusks.

black rhinoceros

Black rhinos feed at night, dawn, and dusk. During the day they take cover from the sun by lying in the shade. Rhinos are wallowers, and often find a suitable water hole and roll in its mud, coating their skin with a natural bug repellent and sunblock.

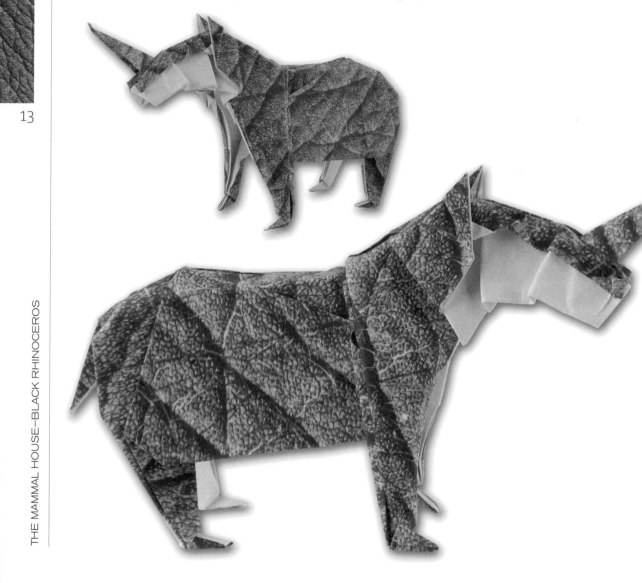

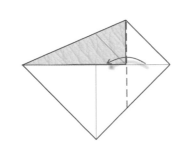

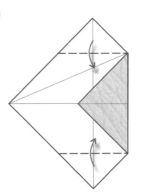

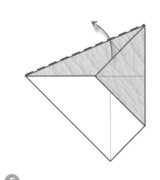

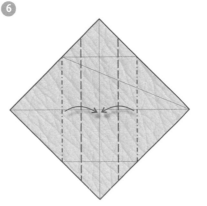

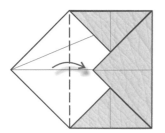

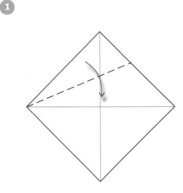

1 Start with a square piece of paper, colored side down. Fold and unfold the square diagonally in both directions. Fold the outer edge to the middle of the square.

2 Bring the right–hand corner of the paper over the folded edge.

3 Pull out the fold made in step 1 from underneath the folded point.

4 Fold the opposing corners in to align the edges with the previously folded corner.

5 Fold in the left corner. This mirrors the opposite side.

6 Unfold back to the full square and then turn the paper over. Fold the sides in and out along the folds made previously and the midline between that crease and the center. Repeat on the other side.

>>

black rhinoceros—continued

7 Fold over the top corner, then fold and unfold the lower section where indicated.

8 Fold up the lower section. At the same time, fold the edges up and carefully open out the folded layers.

9 Fold the point back down along the dotted line, as indicated.

10 Pull out the paper from beneath the lower triangular section.

11 Fold the outer left and right corners behind. Then fold the two triangles down.

12 Fold and unfold where indicated. On the folded triangles, fold and unfold the outer edge to the crease above.

13

7

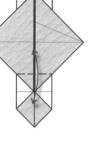

8

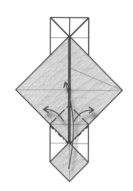

9

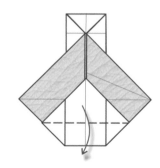

10

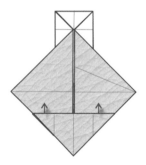

11

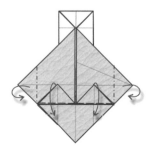

12

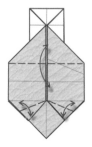

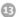

13

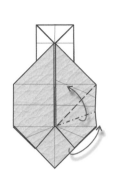

14

15

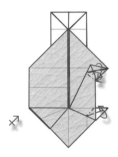

16

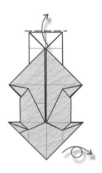

17

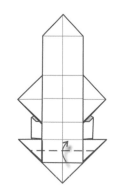

18

13 Start to form what will become the legs: fold up the right side. This will cause the fold made in the previous step to refold.

14 Continue forming the rhinoceros's legs. Fold and unfold the two points on the right side down to the middle.

15 Refold the folds from the previous step. This time, fold the top edges underneath. Repeat on the other side.

16 This section will form the head of the rhinoceros. Fold the top corner back up. Then turn the model over.

17 Fold the lower edge up to the crease line, as indicated.

18 Fold up the lower left and right corners. Fold the lower point up over the folded edge above.

black rhinoceros—continued

19 This section will become the rear legs and the tail. Fold the point back down again as shown by the arrows.

20 Fold in the edges of the lower section. This will cause the paper on either side to fold in as well.

21 To make the rear legs narrower, fold up the left and right corners in the bottom section. Then turn the model over.

22 On the upper section, which will form the head, fold and unfold the right corner.

23 Reverse fold the paper into the model from the folds made previously. While doing this, fold down the lower corner of this section.

24 Fold the edges of the folded top corner back over. Repeat steps 22 to 23 on the other side.

19

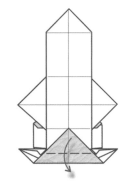

20

21

22

23

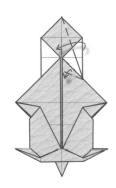

24

(22-23)

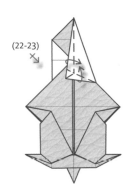

25

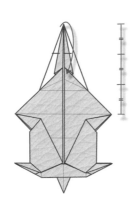

26

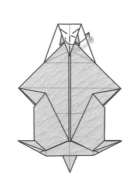

27

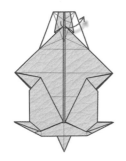

28

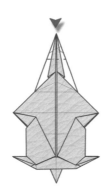

29

30

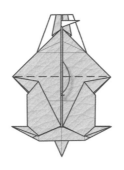

25 Using the scale to determine the proportions of the folds, fold the top section over. This fold should be slightly more than a third of the distance between the point and the crease indicated in the diagram.

26 Pinch the point together and fold over to the right. This will form the horn of the rhino.

27 Unfold the top point of the rhinoceros as indicated.

28 Reverse fold the point of the rhinoceros's horn into the model.

29 Refold the top layer of the reversed point over to the right.

30 Fold the top section of the model down along the horizontal dotted line.

black rhinoceros—continued

31 Fold the outer edges of the front section up to the top folded edge. Then fold the newly formed point to the right.

32 In the middle of the model, at either side, fold the outer edges in to the folded edge.

33 To finish the body of the rhino, fold the model in half along the dotted rule, and then rotate the model 90° clockwise.

34 Fold the head of the rhino down, making crimp folds (see page 14) on the outer layers of the neck.

35 Fold the small triangle at the top of the head over and back again to form the rhino's ears. Repeat behind.

36 Just in front of the base of the ear, fold up the tip of the paper to make an eye. Repeat the fold behind.

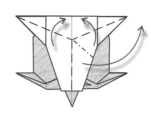

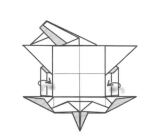

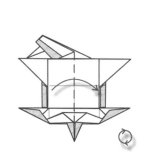

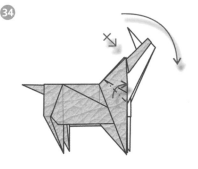

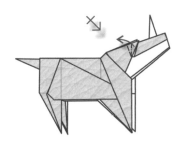

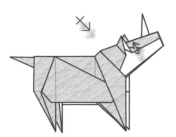

37

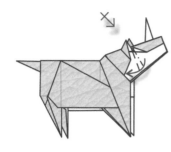

38

39

40

41

42

37 Fold the head down making more crimp folds on the outer layers of the rhino's neck.

38 To give more shape to the head, fold up where indicated. Repeat the fold behind.

39 On the front of the head, fold over a nostril. Reverse fold the tail, then make another crimp fold to move the front legs back.

40 To make the rhino's feet, make a bird's–foot fold at the bottom of each leg.

41 To refine the shape of the head, fold it down, making crimp folds where shown on the outer layers of the nose.

42 Give the body a more three–dimensional shape by sinking the top of the back into the body.

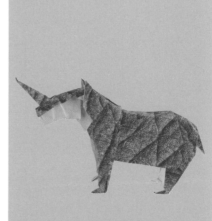

THE MAMMAL HOUSE—BLACK RHINOCEROS

bengal tiger

Bengal tigers live in India and are sometimes called Indian tigers. Living alone, they scent-mark large territories to keep their rivals away. They hunt at night and their prey consists of buffalo, deer, wild pigs, and other large mammals.

14

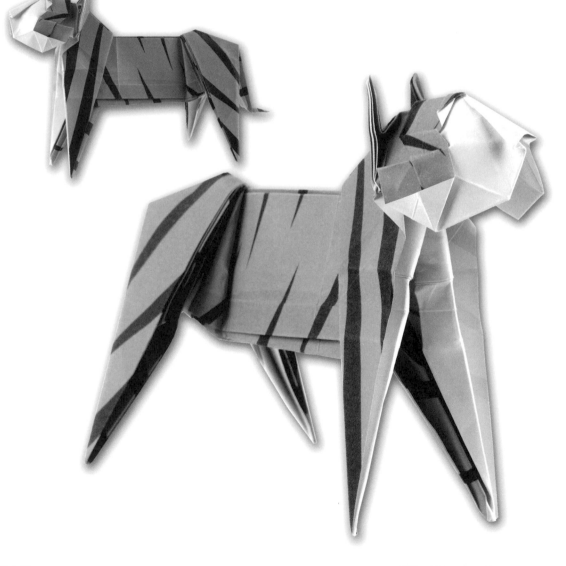

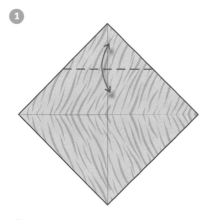

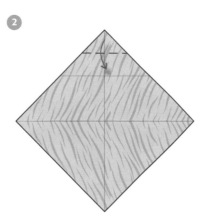

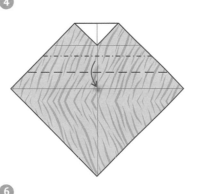

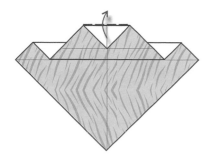

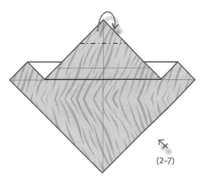

(2–7)

1 Start with a square piece of paper, pattern side up. Fold and unfold the square diagonally in both directions, then fold and unfold the top corner to the middle.

2 Fold the top corner in again to touch the crease made in step 1.

3 Fold and unfold the top edge to align with the middle crease line.

4 Fold the top section down and up again between the crease made in the previous step and the middle line.

5 Fold just the tip of the sheet of paper back up, as indicated.

6 Fold the tip behind, and then repeat steps 2 to 7 on the lower section.

> >

bengal tiger—continued

7 Fold and unfold the right point along the dotted line where indicated.

8 Fold the corners out along the crease made previously. This will cause the point to open.

9 Fold the corner back over to the right along the dotted line.

10 Lift the upper triangle and fold it over in the direction indicated.

11 While folding the triangle back over, fold in the layer beneath. Repeat steps 11 to 12 on the lower side. Turn the model over.

12 Fold and unfold the left-hand point to the crease in the center.

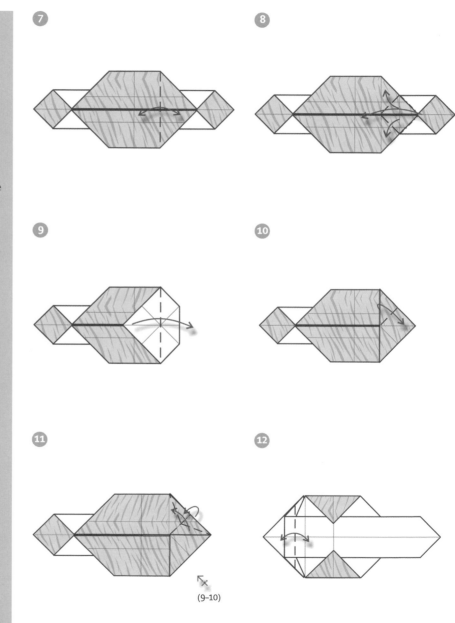

(9–10)

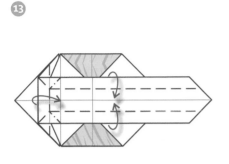

13

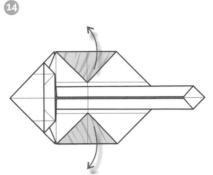

14

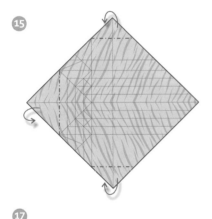

15

16

17

18

13 Working on the middle section, fold the outer edges and refold the previous step.

14 Now carefully unfold the model back to the original square.

15 Fold the upper, lower, and left–hand corners behind, along the creases made previously.

16 Refold the model along all the creases made previously. This is the same folding process as made in step 13.

17 Where the edges of the sections meet, fold and unfold as indicated.

18 Make diagonal folds where indicated, then unfold them.

bengal tiger—continued

19 Fold the front section over along the diagonal fold. At the same time, fold out the corner along the fold made in step 17.

20 Fold the rear section back. While doing so, hold the top half of the triangle beneath in place. The point will open out.

21 Pull out the paper underneath to mirror the upper section.

22 Fold over the left–hand edge as indicated.

23 Make a zigzag shape by folding the tip over and back again.

24 Fold over the right side of the model along the dotted line.

14

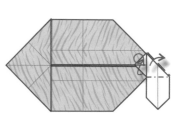

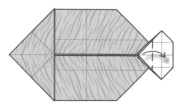

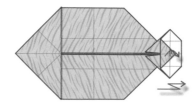

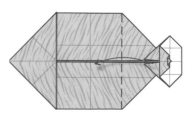

25

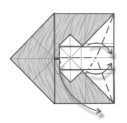

26

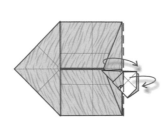

27

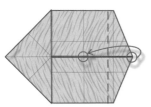

28

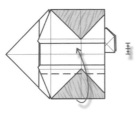

29

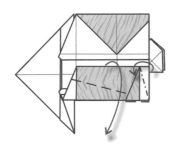

30

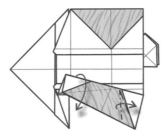

25 This section will become the head. Fold the edges of the upper triangle over together. Fold the point formed by this process downward.

26 Fold the triangle at the front over and the head behind.

27 Using the two circles as reference points, fold the outer corner over to touch the middle crease. Then turn the model over.

28 Fold the lower edge up to the midline between the folded edge and the middle crease.

29 Start to form the front legs by folding the edge back, as indicated.

30 Fold the edge over the front leg. This will cause the paper to the left to fold over.

bengal tiger—continued

31 Continue to form the legs. Fold the edge up again. This will cause a squash fold on the lower right point.

32 Narrow the front legs and fold the edge down. Then fold over the corner at the back. Repeat steps 28 to 32 on the upper portion of the model.

33 Fold the model in half. At the same time, fold in a small triangle of what will become the front shoulders. This will prevent the paper from tearing.

34 Working on the front legs, fold the edges behind. Then tilt the head down slightly.

35 To shape the tiger's head, fold the nose up and squash it. Fold the edge over and behind.

36 Fold up the edge of the cheek, causing a squash fold beneath. Repeat on the other side.

31

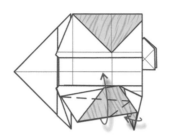

32

(28–32)

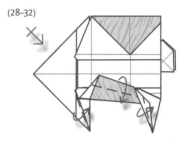

33

34

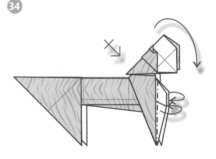

35

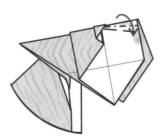

36

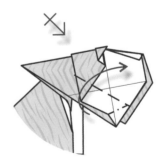

37

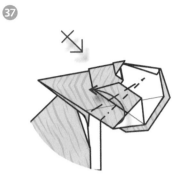

38

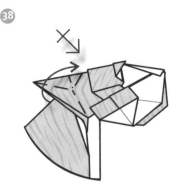

39

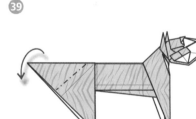

40

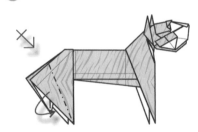

41

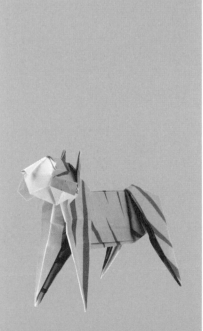

37 Crimp fold up the cheek to add shape to the face. Repeat on the other side.

38 To create the ears, fold the point in half and bring it up at a right angle. Repeat on the other side of the tiger's head.

39 Reverse fold the rear point of the model to start forming the tail of the tiger.

40 Narrow the tail and the rear legs by folding them in where shown. Repeat on the other side.

41 Thin the tail once again. Finally, crimp the whole body to add some shape to the rear section of the model.

mexican tarantula

Many people are scared of tarantulas because of their large, hairy bodies and legs. But these spiders are harmless to humans—though their bite is painful, their mild venom is actually weaker than a common bee's.

15

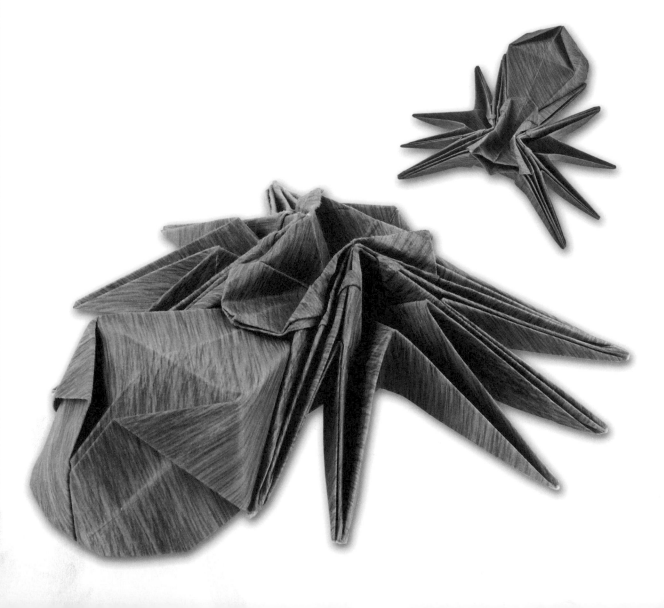

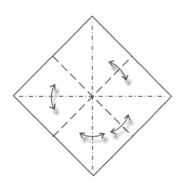

1

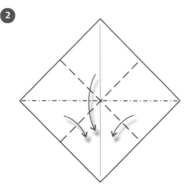

2

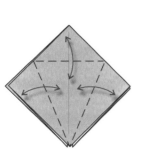

3

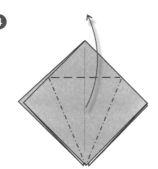

4

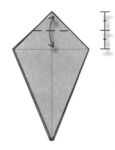

5

6

1 Start with a square piece of paper, colored side down. Fold and unfold the square in half horizontally, vertically, and diagonally. The diagonal folds should be mountain folds.

2 Refold the creases made previously. This will form a preliminary base (see page 13).

3 Fold both outside edges to the middle, then fold over the top triangle. Then unfold all of them.

4 Lift the front layer up and fold along the horizontal crease made in step 3.

5 Bring the front point down and fold. Repeat steps 3 to 4 on the other side.

6 Fold and unfold the the point at the top to the midline between the top of the model and the lower crease.

(3-4)

INSECTS AND SPIDERS—MEXICAN TARANTULA

> >

mexican tarantula—continued

7 Reverse the top triangle into the body of the model as indicated.

8 Lift up the front and rear lower points and fold as indicated.

9 Fold over one layer at the front and one layer from behind.

10 Bring up the front and rear points and fold them as shown.

11 Fold the paper in the front layer out to the folded edge. This will open out the point.

12 Make a crease where indicated by folding and unfolding the lower triangle, as shown.

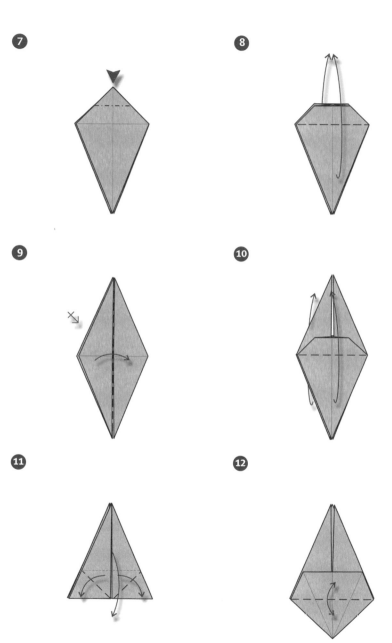

13

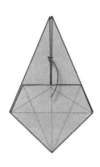

14

15

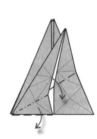

16

17

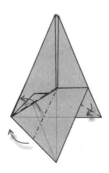

18

13 On the top layer, fold and unfold both of the outer corners to the crease made previously.

14 Lift and open the folded section of the model back up, as indicated.

15 Fold and unfold the left side of the model along the dotted line to the base.

16 Bring the point of the section diagonally down and fold it while opening up one side.

17 Fold the edge back up, and re-form the folded section.

18 Fold the right side of the model down and slide the left side up.

mexican tarantula—continued

19 Pull out the paper trapped beneath the folded layer.

20 Fold the layer back up again to re–form the folded section.

21 Fold and unfold the top point of the model to the crease below.

22 Reverse fold the point into the model along the crease made previously.

23 Fold over the top layer of the model from right to left.

24 Make a small fold on the indicated corner along the dotted line.

25 Fold up the layer on the right–hand side of the model to the center line.

26 Fold the point back, then narrow the folded point beneath along the dotted lines.

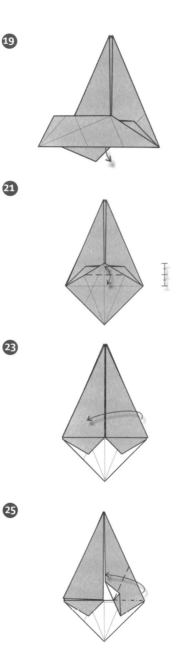

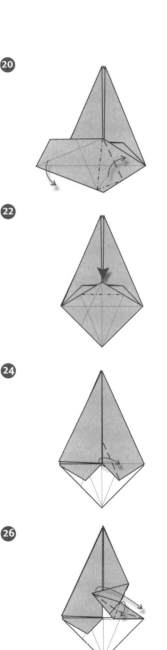

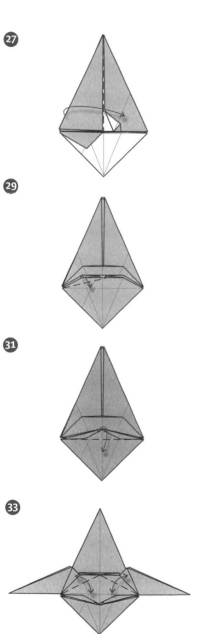

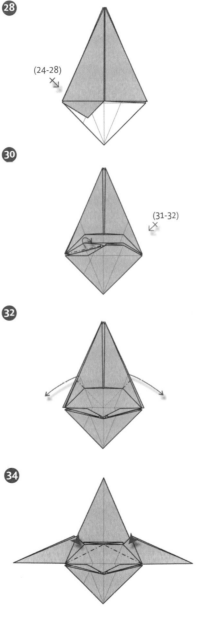

27 Fold the top layer back over from left to right, as indicated.

28 Turn the model over and repeat steps 24 to 28 on the other side.

29 Fold over the left edge of the front layer.

30 Fold the indicated edge behind, then repeat steps 31 to 32 on the other side.

31 Fold the center of the lower triangle section of the model down.

32 Reverse fold the left- and right-hand outer points to start forming the legs.

33 Fold and unfold the left and right corners of the middle section, as shown.

34 Sink fold the corners along the creases made in the previous step.

INSECTS AND SPIDERS—MEXICAN TARANTULA

mexican tarantula—continued

35 On the middle section of the spider, fold and unfold the corners as shown.

36 Sink fold the corners along the creases made in the previous step.

37 Fold the sink-folded point down, and then open out the sides of the section.

38 Fold the lower edge of the front section back up.

39 Fold the corners of the middle section over as indicated.

40 Bring the lower corner of the front section back up, as shown.

41 Repeat steps 11 to 31 and then 33 to 40 on the other side of the model.

42 Fold the front layer over to the left. This will cause the left-hand folded point to open out and upward.

35

36

37

38

39

40

41

(11-31)
(33-40)

42

43
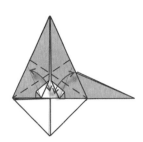

44
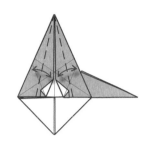

45
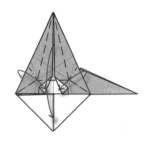

46
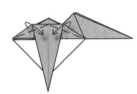

47
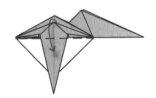

48
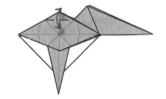

49
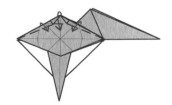

50
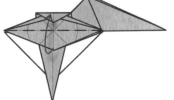

43 Fold and unfold the edges of the top triangle diagonally to the base.

44 Fold and unfold the edges of the top triangle to the middle crease line of the model.

45 Bring the point down and refold the creases made in the previous two steps.

46 Fold in the outer right and left corners of the front section of the model, as shown.

47 Fold the center of the top front section down the vertical point.

48 Fold, crease, and unfold the tip of the forward section.

49 Fold over all the edges of the front section. Also fold over the tip section that you folded in the previous step.

50 Fold the lower edge of the front section of the spider back up.

INSECTS AND SPIDERS—MEXICAN TARANTULA

mexican tarantula—continued

51 Continue to make the layers that will form the legs. Fold the right-hand side of the top layer back over to the left.

52 Fold the edge of the rear section down. Fold over a small corner of the middle section. Repeat on the other side.

53 Fold the edges of the rear section behind. Now make a reverse fold on the protruding triangle in the middle section.

54 Fold over the edge of the inner section. Then fold up the corner. Repeat behind.

55 Bring down the tip of the triangle and fold. Then make two diagonal folds, as shown, along the dotted lines.

56 Reverse fold the ridges of the front section. Then repeat steps 55–56 on the other side.

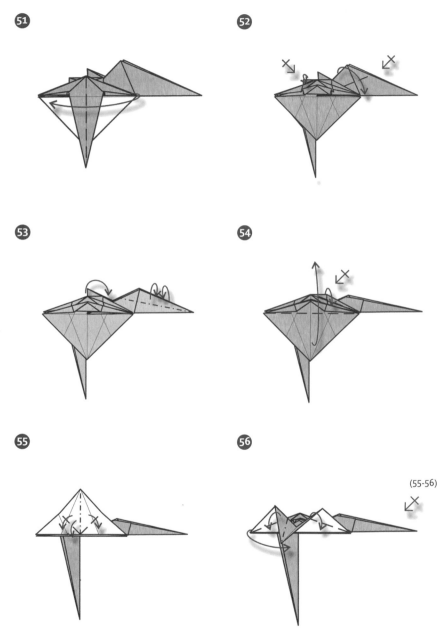

51

52

53

54

55

56

(55-56)

57

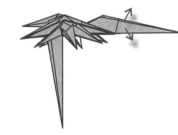

58

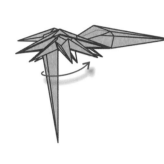

59

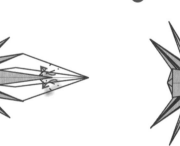

60

61

57 Open out the edges of the rear section of the spider. This will be the body.

58 Fold up the lower left point to the base of the model.

59 These steps show the underside of the model. Fold the tips of the rear section together to form a diamond. This will give the body section a rounder shape.

60 Fold the diamond shape over, then fold the folded point over.

61 Finally, fold the edges of the diamond shape around the point beneath. Fold the corners over to round the spider's abdomen. Turn the model over. The spider is complete.

longhorn beetle

The longhorn beetle is a large family of beetles characterized by extremely long antennae, which are often as long as or longer than the beetle's body.

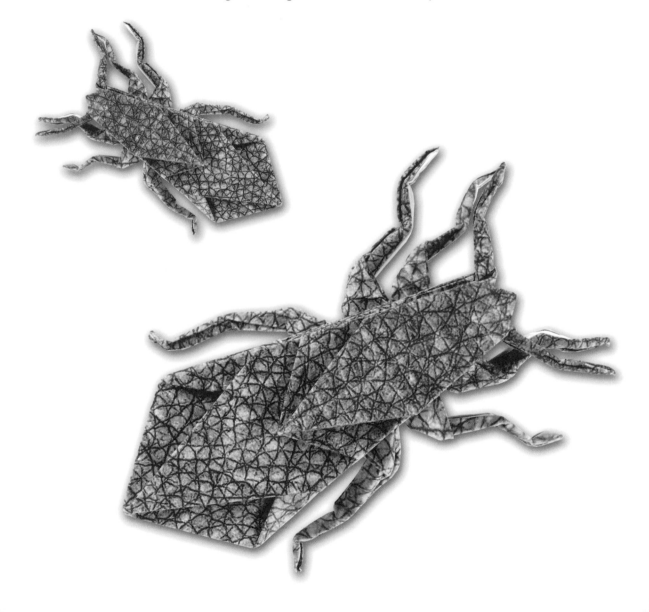

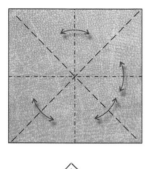

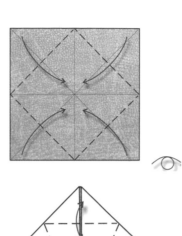

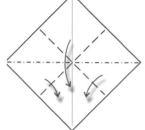

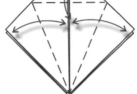

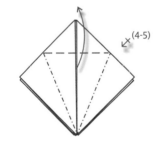

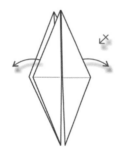

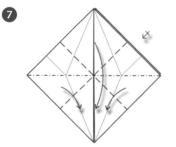

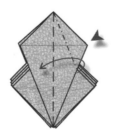

1 Start with a square piece of paper, colored side up. Fold and unfold the square horizontally, vertically, and diagonally. Make the lengthwise folds mountain folds.

2 Fold the four corners into the middle. Then turn the model over.

3 Refold the folds made in step 1 to form a preliminary base (see page 13).

4 Fold the outside edges in to the middle. Fold over the top triangle, then unfold.

5 Fold the front layer up along the crease made in step 4. Repeat steps 4 to 5 on the other side.

6 Open out the paper that is folded behind the front layer. Repeat on the other side.

7 Bring the top section down and fold it in along the diagonal creases. This creates a preliminary base shape. Repeat on the other side.

8 Take the front lower right–hand corner and fold it over, then open out the upper section and squash the corner.

INSECTS AND SPIDERS—LONGHORN BEETLE

> >

longhorn beetle—continued

9 Fold over the lower right-hand corner and squash it flat.

10 On the lower section, fold and unfold the edges to the middle crease line.

11 Lift the top layer up. This will cause the edges to fold to the center of the model.

12 Now fold down the triangle you just folded, as indicated.

13 Fold the rear layer back over to the right. Repeat steps 8 to 13 on the left-hand side, then turn the model over.

14 Repeat steps 8 to 13 on the right-hand side of the beetle.

15 Grasp the layer below the front point. Pull the edges out to open out the folded front section.

16 Refold along the creases made previously. Bring the folded section to the front.

9
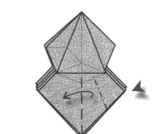

10
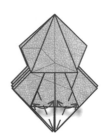

11
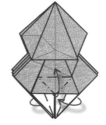

12
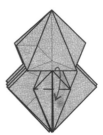

13
(8-13)
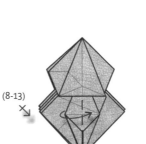

14
(8-13)
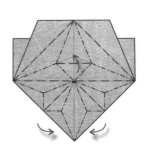 

15

16

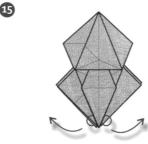

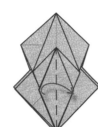

17

18

19

20

21

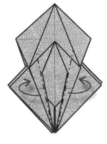

22

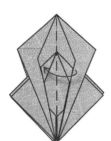

23

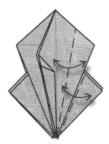

24

17 Fold one layer of the left side over to the right–hand side.

18 Fold the tip of the front layer inside the model.

19 Fold the left and right edges of the front layer behind.

20 Fold over two layers from the right side. The front should look like it did in step 19.

21 Continue folding the left and right edges of the front layer behind.

22 Carefully fold the edges of the lower layer of the model behind.

23 Fold over the top two layers of the model from right to left.

24 Fold and unfold the kite shape to the middle. Then fold and unfold the lower triangle along the edge of the kite shape.

longhorn beetle—continued

25 Fold and unfold the two layers of the lower right-hand edge to the edge of the kite shape. Then fold the top left layer back to the face shown in step 21.

26 Repeat steps 22 to 25 on the other side of the beetle's body.

27 Lift up the folded corners and open up the model.

28 Refold the open section. Reverse fold along the creases and fold the model will fold flat.

29 Fold one layer over to the face, as shown in step 23.

30 Fold over the crease made in step 22. Squash the top corner, then fold back the layers on the right side.

31 Repeat steps 29 to 30 on the other side. Then turn the model over.

32 Fold the layer on the lower left-hand side over to the right–hand side.

25
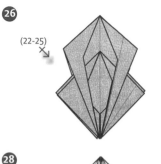

26
(22-25)
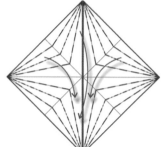

27
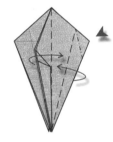

28

29

30
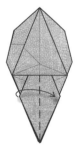

31
(29-30)

32

33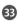

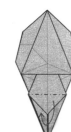

34

35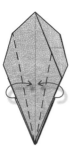

36

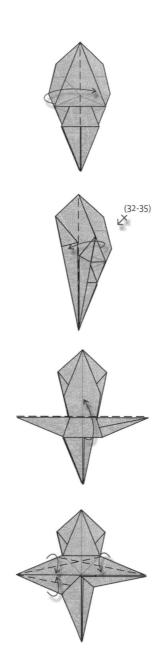

(32-35)

37

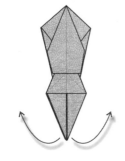

38

39

40

33 Fold the tip behind and into the body of the beetle.

34 Bring over the top section of the model from left to right.

35 Fold the left and right outer edges of the model in to the middle.

36 Fold the layer back over. Then repeat steps 32 to 35 on the right side.

37 Check that the model has four points on each side. If it doesn't, fold a layer over to correct this. Then fold up the points where indicated to start creating the legs.

38 Lift up the front edge of the model, and then open up the points.

39 Reverse fold the lower left–hand corner into the model.

40 Fold the three edges indicated in to the middle of the beetle's body.

INSECTS AND SPIDERS—LONGHORN BEETLE

longhorn beetle—continued

41 Now work on the legs of the beetle. Fold the lower edges of the left and right horizontal points up, as shown.

42 Fold the lower left edge of the point in toward the center of the model.

43 Reverse fold out two more points to continue forming the legs.

44 Reverse fold the third pair of legs from the lower layer.

45 Make reverse folds on all the legs to give them a more realistic shape.

46 Narrow each leg down by carefully folding the edges inside.

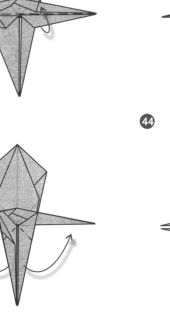
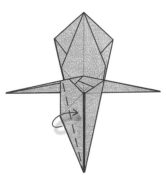
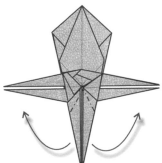
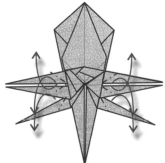
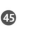
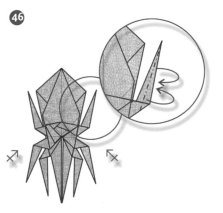

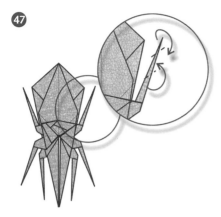

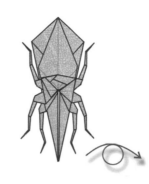

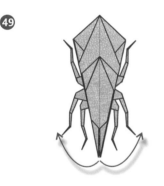

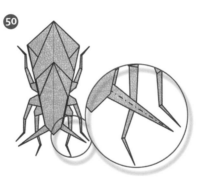

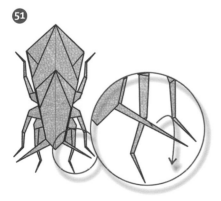

47 Make two more reverse folds on each leg, where indicated, to shape them.

48 Turn the model over.

49 Pull out the front two points to create the beetle's antennae.

50 Narrow the beetle's antennae by folding the edges inside.

51 Bend and shape the antennae and adjust the legs to make the beetle look as realistic as possible.

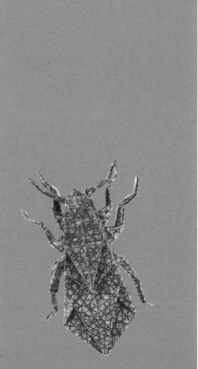

INSECTS AND SPIDERS—LONGHORN BEETLE

index